IMAGES
of America
WOONSOCKET
REVISITED

The city of Woonsocket was once the center for many textile mills that made this urban area one of the world's premier woolen and cotton industrial sites. Yet, some unique products carried the name of the city. They had the name of Woonsockets. These items were rubber shoes and boots. At its peak, the Woonsocket Rubber Company produced in its three big mills 40,000 pairs of rubber boots and shoes a day. The company produced more than 200 different styles and more than 2,000 different shapes and sizes. An advertisement in 1896 boasted that "if there's a foot on earth that can't get a perfect fit with 2,000 chances in its favor, it must be a funny foot." Another advertisement from the end of the 19th century proclaimed in verse:

> Now, there are Rubbers worth one's while,
> So slender, trim and full of style,
> If you'd as stylish be as dry,
> Woonsocket Rubbers always buy.

IMAGES of America
WOONSOCKET REVISITED

Robert R. Bellerose

Copyright © 2004 by Robert R. Bellerose
ISBN 0-7385-3619-9

First published 2004

Published by Arcadia Publishing,
Charleston SC, Chicago IL, Portsmouth NH, San Francisco CA

Printed in Great Britain

Library of Congress Catalog Card Number: 2004104495

For all general information, contact Arcadia Publishing:
Telephone 843-853-2070
Fax 843-853-0044
E-mail sales@arcadiapublishing.com
For customer service and orders:
Toll-free 1-888-313-2665

Visit us on the Internet at www.arcadiapublishing.com

The history of Woonsocket is rich in stories involving immigrants. These stories began with the early Colonial settlers of the 17th and 18th centuries and the Irish of the early 19th century. The immigration continued with the French Canadians in the late 19th century and the various European nationalities who arrived throughout the early 20th century. This story continues with today's immigrants from Africa, Asia, and Central America, all seeking a better life. Immigrants to Woonsocket worked the mills and endured low-paying jobs and grim factory conditions, eventually acclimating to American life and enjoying the bounty of the United States of America. This view from the dawn of the 20th century typifies the can-do spirit of these immigrants and their contributions to the nation's great standard of living.

CONTENTS

Acknowledgments		6
Introduction		7
1.	Along the Blackstone River	9
2.	Business, Trade Cards, and Advertisements	15
3.	The Changing Landscape of Woonsocket	37
4.	The Woonsocket Rubber Company's Alice Mill	57
5.	The Flood and the Hurricane of 1938	67
6.	The Blackstone Valley Gas and Electric Company	75
7.	Festivals, Celebrations, and Parades	85
8.	Community Services	93
9.	Remembering the Mills	109
10.	Places of Worship, Comfort, and Rest	115

Acknowledgments

I would like to extend a thank-you to A. Raymond Auclair for his generous donation of historical books, photographs, and materials to the American-French Genealogical Society in Woonsocket. Without his kind permission to use the materials from the collection, this book would not have been possible.

A word of thanks also needs to be extended to Roger Bartholomy, president, Sylvia Bartholomy, publicist, and the board of directors of the American-French Genealogical Society, who have supported this project from conception to completion.

I extend a word of thanks to Phillip A. Levesque of Cumberland, who a number of years ago donated a collection of photographs to me. Without his generous donation, the chapter on the Blackstone Valley Gas and Electric Company would not have been possible.

Finally, I would like to thank my dear wife, Therese, who through patience and encouragement helped me tremendously throughout this endeavor. Her reading of the text and contribution of ideas were greatly appreciated.

INTRODUCTION

This project came about after A. Raymond Auclair made a generous donation of books and other historical items to the American-French Genealogical Society in Woonsocket. These books and historical materials collectively became a memorial to Raymond Auclair's father, Alphonse F. Auclair. The collection comprises an assortment of materials that includes books, pamphlets, serials, photographs, stereographs, slides, broadsides, and maps. The items represent an interest in the history of the Blackstone River Valley and the state of Rhode Island. These materials were collected over a span of approximately 30 years.

The printed collection consists of approximately 1,000 books, pamphlets, and serials. These materials, taken together, present a comprehensive overview of the history of the state of Rhode Island and Providence Plantations. There is a concentration of material related to the history of the cities and towns located along the Blackstone River. Also, there are approximately 25 titles that cover various aspects of Rhode Island genealogy. Printing dates on these materials span from c. 1834 to 2000.

What truly brings the history to life is the large collection of historical photographs that accompanied this donation. Besides standard photographs, the gift included postcards, stereographs, slides, broadsides, and maps. The photographs, which date from 1860 to 2000, depict scenes, events, and historical structures throughout Providence County in the state of Rhode Island. The broadsides and maps also help to bring various aspects of the Blackstone River Valley to life.

The benefits of the collection to the American-French Genealogical Society and local scholarship are enormous. Auclair's donation expands the current focus of the American-French Genealogical Society library to include cultural and historical materials not directly related to French Canadians. What this collection does is help place in a larger context the French experience in Rhode Island and especially in the Blackstone River Valley. Genealogists and scholars now can use the society's library for genealogical, cultural, and historical research.

The photographic material in the collection, although a new feature of the society's library, provides a visual aspect to historical inquiry. Photographs, maps, and the other miscellaneous material contribute to bringing to life the French experience in the Blackstone River Valley.

The idea for creating *Woonsocket Revisited* was twofold. First, as part of Arcadia's successful Images of America series, this volume would serve the public and scholars as a wonderful introduction to a small sampling of the photographic resources of the Alphonse F. Auclair Collection at the American-French Genealogical Society Library. Unless otherwise noted, all photographs in this volume are from the Alphonse F. Auclair Collection in the American-French Genealogical Society Library in Woonsocket. Second, this book would serve as a fund-raiser to help pay for the proper archival storage of these photographic items. All royalty payments from the sale of this book go to the American-French Genealogical Society's Library Fund.

The library of the American-French Genealogical Society is located in the basement of the First Universalist Church, at 78 Earle Street, Woonsocket. The society, which is nonprofit, is a genealogical and historical organization founded in 1978. The purpose of the society is to preserve and study Franco-American heritage and to aid society members in discovering their ancestors. The society has an active publishing division devoted to distributing vital statistics, parish registers, burial records, and other data useful to Franco-American research.

The library consists of more than 6,000 volumes of marriage records, genealogies, biographies, and histories. There is also an extensive microfilm collection available for use that augments the printed materials. Some specialized collections that the society owns include the Drouin, Loiselle, Rivest, and Fabian Files. These records document more than two million French Canadian marriages, and many of the records cover the most difficult period to research. Of note to genealogists are the Forget Files, of Dr. Ulysse Forget, which record thousands of Franco-American marriages in Rhode Island.

During library hours, individual assistance and instruction are available for new members. Experienced and highly competent members provide these services.

Information may be obtained by writing to the American-French Genealogical Society, P.O. Box 830, Woonsocket, RI, 02895-0870. The Web site is www.afgs.org.

One
ALONG THE
BLACKSTONE RIVER

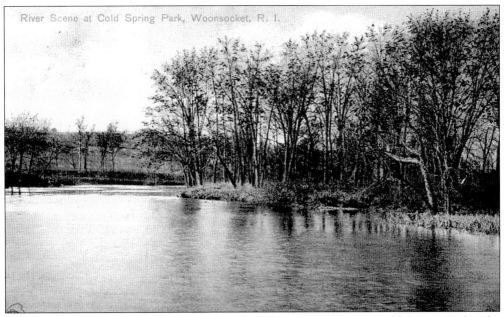

Photographed in 1903 is this scene along the Blackstone River at Cold Spring Park. The Woonsocket City Council on April 13, 1891, approved the acquisition of 25 acres in Cold Spring Grove to create Cold Spring Park. This area, off Harris Avenue, has been a site of leisure at least since the beginning of the 1840s. At that time, the supporters of a liberalized state constitution, known as Dorrites, held huge clambakes and rallies here. This and the following images follow the Blackstone River as it flows into the city at its northwest corner and flows out at its southeast corner.

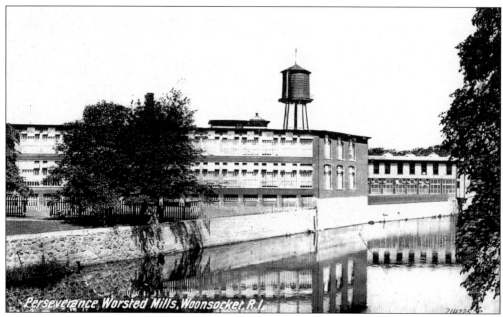
The Perseverance Worsted Mills, along the Blackstone River, is shown at the dawn of the 20th century. The Singleton family started this company in 1880 and, by the year 1900, employed 233 workers.

Woonsocket Falls was photographed during high water c. 1940. The falls along the Blackstone River produced such an abundance of power that the city literally grew from this locale. Market Square, seen beyond the falls, contained an abundance of factories, all drawing power from the river. In the late 1960s, this scene changed dramatically as the mills fell victim to the wrecking ball and the land became parking space for automobiles.

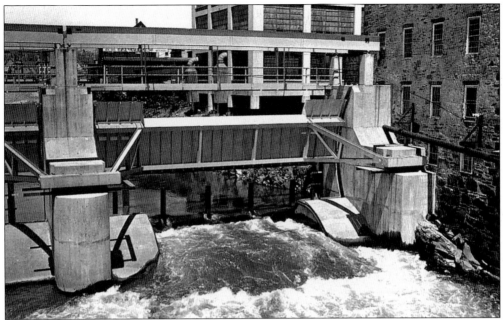

The Blackstone River Dam, or Globe Dam, is seen from the Globe Bridge c. 1960. This steel-and-concrete structure, built by the U.S. Army Corps of Engineers at a cost of $1 million, contains four gates to regulate the flow of water downriver from the dam. The mills on the right are no longer standing, as they were demolished in the 1960s to make way for a municipal parking lot.

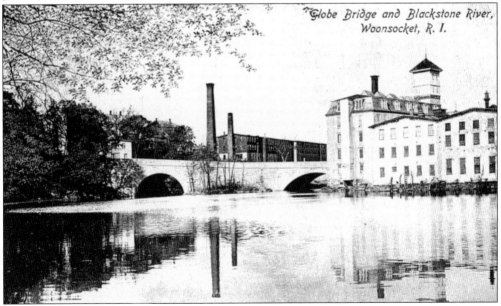

Pictured upriver is the Globe Bridge, spanning the Blackstone River, c. 1910. Some readers may remember the structures on the right as part of the former Falls Yarn Mill complex. The Falls Yarn Mill began operation in 1900. A small portion of this complex is still standing and currently houses the Walsh and Burlingame Florist Shop. Today, the Thundermist Hydroelectric Plant, dedicated on June 19, 1982, stands next to the Globe Bridge.

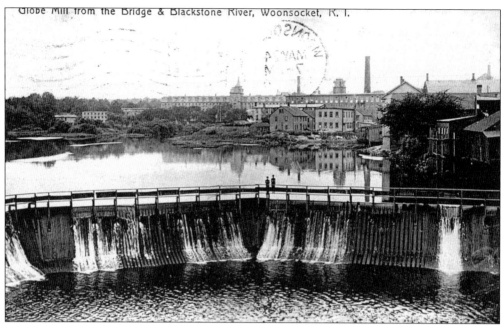

Shown are the Globe Mill and the Blackstone River, as photographed from the Bernon Street Bridge c. 1909. In the foreground is the Bernon Dam, which created a huge millpond to supply water to the Woonsocket Company mills along Front Street. In the background is the Globe Mill, situated along Front Street. The structures on the right are on Bernon Street. The buildings in front of the Globe Mill are on a strip of land called the island.

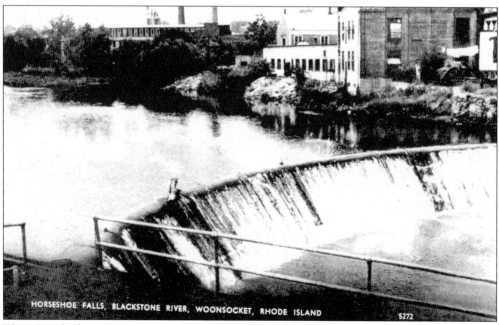

This view, looking upriver c. 1940, depicts the Bernon Dam across the Blackstone River. The postcard incorrectly identifies the dam as Horseshoe Falls. The structures on the right front Bernon Street.

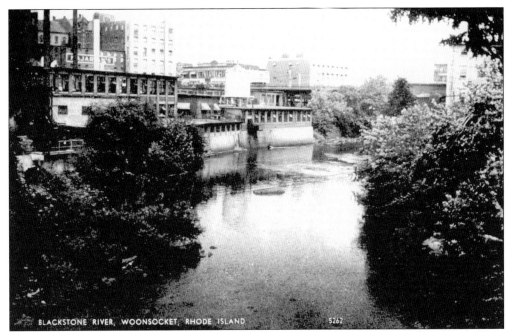

The Blackstone River is shown from the Bernon Street Bridge c. 1940. The mill buildings along the river still stand today on Allen Street. The other buildings, in the distance on the left, are on Main Street. Visible are Najarian's Department Store, the Globe Building, the Court Street Bridge, and the Blackstone Hotel.

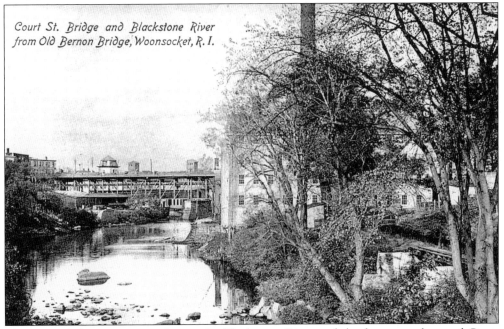

This c. 1900 downriver view depicts the Blackstone River and the former steel-trussed Court Street Bridge in the distance. Construction of this bridge was begun in 1893, and the dedication was held on June 22, 1895. The mills on the right once belonged to the Woonsocket Company. In the early 19th century, they were part of the mill village of Bernon.

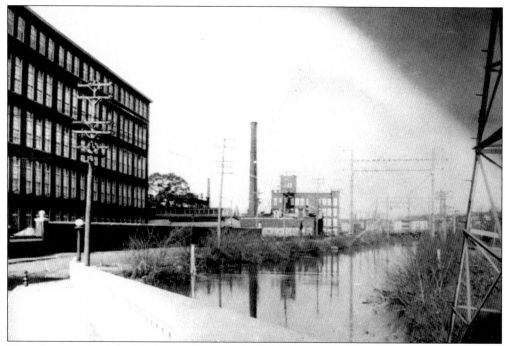

This photograph of the Blackstone River was taken from the Hamlet Avenue Bridge c. 1940. Part of the former Lafayette Worsted Mill is on the left. In the distance is the former River Spinning Mill, which was built in 1894 and destroyed in a spectacular fire in 2003.

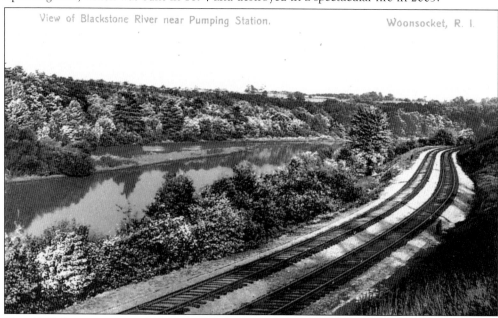

This 1909 downriver view depicts the Blackstone River near the pumping station at the border between Woonsocket and the towns of North Smithfield and Lincoln. The Blackstone River flows out of the city at the southeast corner. The railroad tracks in the foreground are those of the Providence & Worcester Railroad. At the time of this photograph, the railroad was under a lease to the New York, New Haven & Hartford Railroad Company.

Two
BUSINESS, TRADE CARDS, AND ADVERTISEMENTS

This c. 1900 advertising card announces J. H. Evans as the sales agent for H. F. Burdick, confectioner. At 61 Railroad Street, Burdick manufactured and sold an assortment of bonbons and candies, and even dabbled in ice cream. A Burdick specialty was Sparrow's chocolates.

From Hon. E. L. FREEMAN, Editor of Weekly Visitor, Central Falls, R. I.— "DR. SETH ARNOLD'S COUGH KILLER has been used by myself personally and in my family with most satisfactory results. I regard it as the best medicine for the purposes for which it is recommended with which I am acquainted."

Dr. T. B. MYERS, of David City, Neb. writes: "DR. SETH ARNOLD'S COUGH KILLER is the best remedy for Whooping Cough and Measles I ever saw."

I have used DR. SETH ARNOLD'S COUGH KILLER for a number of years and can say that for coughs and colds it is the best medicine I ever used.

Mrs. Wm. F. Manchester,
Fall River, Mass.

—PREPARED ONLY BY THE—

Dr. SETH ARNOLD MEDICAL CO.
WOONSOCKET, R. I.

This advertising card from the 19th century extols the virtues of Dr. Seth Arnold's Cough Killer. The Dr. Seth Arnold Medical Company manufactured an assortment of patent medicines. These were trademarked medical preparations usually containing secret ingredients or made by secret formula. By the 1870s, Arnold bought the structure at 234–240 Greene Street, which became known as the Dr. Arnold Building. The structure remains today, having been converted into an apartment house.

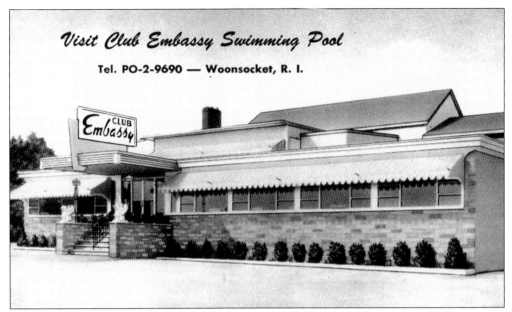

This c. 1950 view shows the Club Embassy, at 77 Havelock Street. Originally a social organization, the club evolved through the years, offering everything from a pool of water used for swimming by its membership to an elaborate banquet palace. This restaurant was the site of numerous formal dinners and feasts. Today, this facility continues to serve as a restaurant open to the public, with accommodations available for large functions.

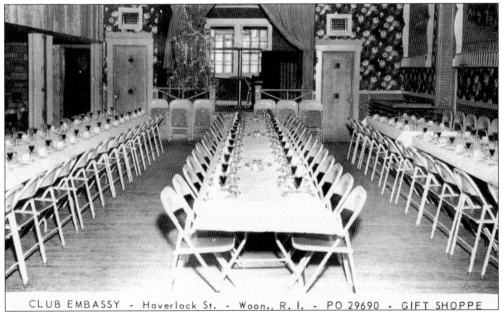

This c. 1950 photograph shows one of the dining halls within the Club Embassy, at 77 Havelock Street. Today, it is known as the Embassy Restaurant and Banquet Facility and is a full-menu restaurant that caters especially to banquets and weddings.

Woonsocket Brush Co.

Makers of Brushes and Brooms.

103 Railroad Street,

Presented by:

Woonsocket, R. I.

Albert L. Bibeault, a representative of the Woonsocket Brush Company, used this business card, which dates from *c.* 1900. This company, located at 103 Railroad Street, was a manufacturer of brushes and brooms.

Here is a business card for Charles E. Delmage, dating from *c.* 1900. Delmage, a "dealer in fruit and confectionery," operated his store at 130 Main Street. The store offered a large variety of fresh fruit as well as assorted bonbons and candies.

| BATTIE SMITH. | A. B. BENSON. |

SMITH & BENSON,

DEALERS IN LADIES', GENTS', MISSES' AND CHILDREN'S

FINE BOOTS, SHOES AND RUBBERS.

SPECIAL ATTENTION GIVEN TO NEW YORK GOODS.

No. 174　　WOONSOCKET,　　Main St.

Dated 1874 on the back, this business card announces the Smith and Benson footwear shop, which was located at 174 Main Street, near Depot Square. The shop's proprietors, Battie Smith and A. B. Benson, were "dealers in ladies', gents', misses' and children's fine boots, shoes and rubbers. Special attention given to New York goods."

J. B. Hough used this business card, which dates from the 19th century. Hough, a "dealer in boots, shoes and rubbers," operated his store at 16 Main Street, near Market Square.

This advertising card for the Woonsocket Rubber Company dates from the 19th century. Primarily a manufacturer of rubber footwear, the company used as its slogan, "Always buy the Woonsocket specialties, they excel all others." Joseph Banigan was the owner and president of the Woonsocket Rubber Company during this time.

Here is another advertising card from the Woonsocket Rubber Company. "Ever wear rubber boots? Want to know the best boot made? It's the Woonsocket—famous these 50 years. Your father wore them—his father, too. Sold wherever shoes are sold and every Woonsocket Boot has the Elephant Head trade-mark."

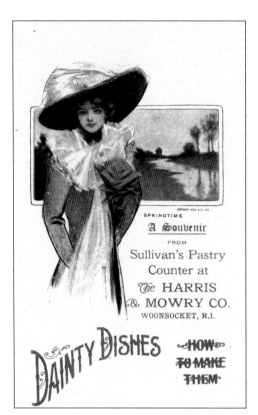

This is the cover to a souvenir cookbook from Sullivan's Pastry Counter at the Harris and Mowry Company, on Main Street. The item dates from the beginning of the 20th century. The collection of "Dainty Dishes" contains recipes and other information for the preparation of food.

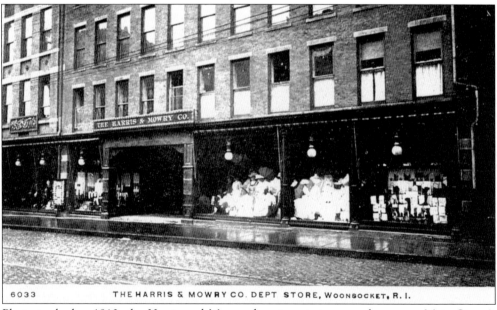

Photographed c. 1910, the Harris and Mowry department store was known as Main Street's "Big Store." It employed 153 clerks and was the city's major mercantile establishment. As with so many buildings that once graced Main Street, the store is no longer standing.

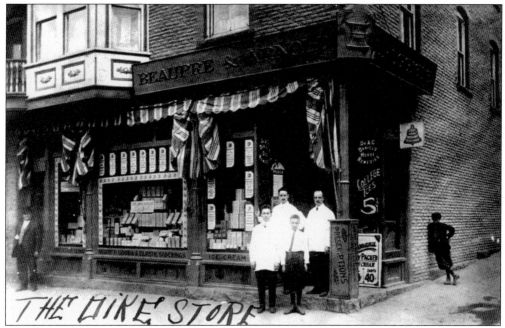

This photograph of the Beaupre and Arnold drugstore was taken c. 1919. E. Arthur Beaupre and C. Seth Arnold operated the store on River Street at the corner of Sayles Street. Besides selling drugs and medical equipment and filling prescriptions, the store offered customers ice-cream sodas, college ices, ice cream, and even a drink called Moxie. The handwritten inscription refers to the window display for a product called "the Dike Shield."

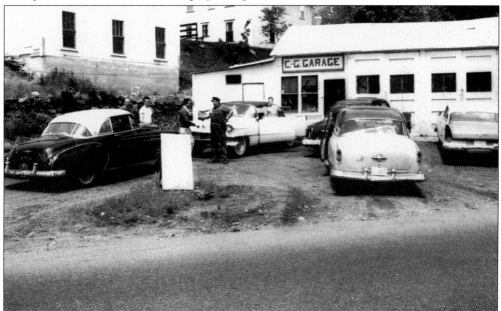

This scene shows the C&G Garage, located on Cass Avenue, c. 1955. The automobile repair shop was near the intersection of Cass Avenue and Elm Street. Later, this site was transformed into Auclair's Home Appliance Store and was operated for many years by Alphonse F. Auclair and his family. The structure was recently converted into a neighborhood variety store.

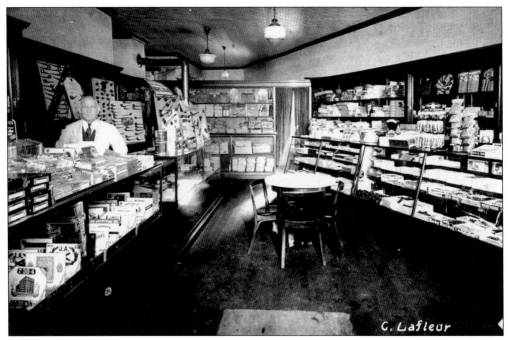

Lafleur's Confectionary and Smoke Shop, operated by C. Lafleur, is shown c. 1933. Within this shop, located at 491 Social Street, customers could purchase a variety of candies and smoking-related items.

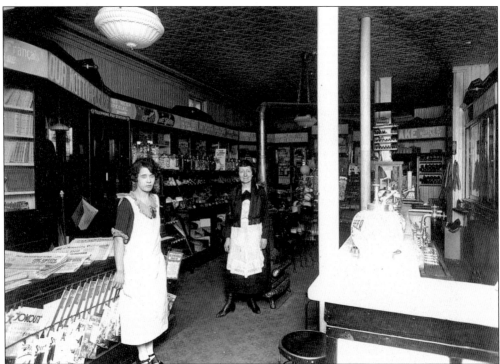

The interior of Godin's, on Cumberland Street, is pictured c. 1900. Customers could buy anything from newspapers to Life Savers, soda, and stationery.

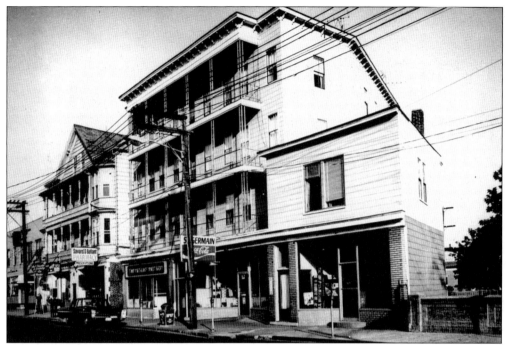

The St. Germain store, on Social Street, is shown c. 1970. On the left of the variety store, at ground level of this huge tenement house, is the office of the Woonsocket Redevelopment Agency. The next structure houses the Savard and Gallant pharmacy. This scene disappeared when the "Social Flatlands" were leveled and revitalized during the 1970s and 1980s.

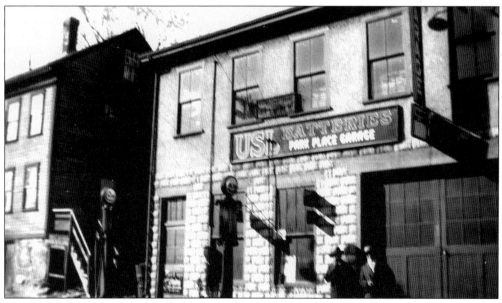

The Park Place Garage, at Park Place, is shown c. 1920. Besides selling USL batteries, this business also stored, repaired, washed, and greased automobiles.

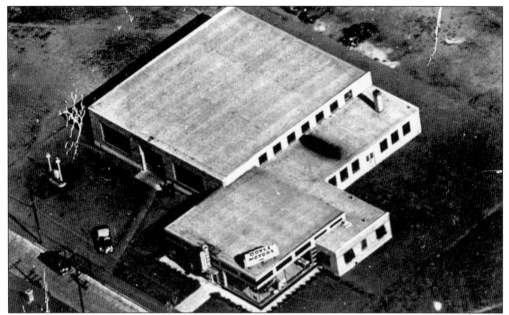

Doyle Motors, at Pond and Snow Streets, is pictured c. 1950. The business advertised that it was the home for "Dodge Job Rated Trucks." Today, this site houses the Rhode Island Department of Labor and Training.

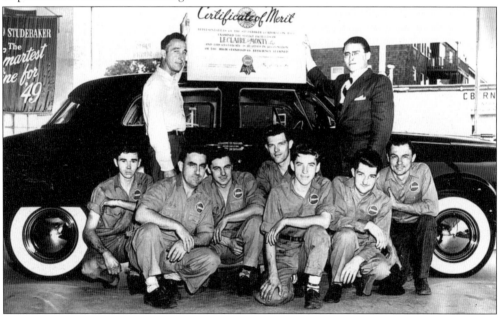

Pictured in 1949 are Benny Monty, holding a certificate of merit, and an unidentified Studebaker representative. The certificate was an award to the service facilities of Leclaire and Monty, located at 360 Social Street, "in recognition of the high standard of efficiency attained." Kneeling are, from left to right, two unidentified individuals, Mauris Tancrell, Frank Super, unidentified, Adrien Bealeau, and Emil Kesior. Besides selling Studebaker cars, Leclaire and Monty provided authorized sales and service for electrical appliances, radios, washing machines, refrigerators, and everything electrical for the home.

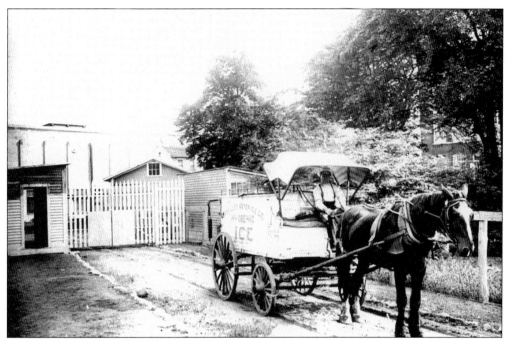

A wagon of the Distilled Water Ice Company is pictured at the company's facilities, at 129 Ballou Street, c. 1911. The company advertised that it delivered "hygienic ice," a product that was said to promote health and sanitation.

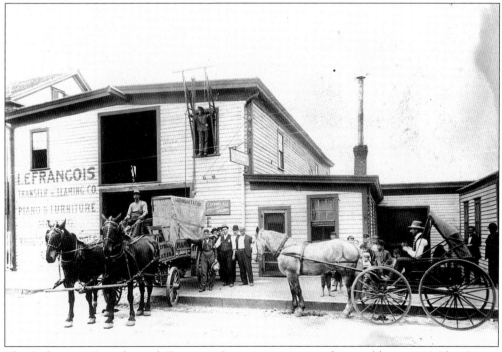

The Lefrancois Transfer and Teaming Company maintained its stables at 266 Elm Street, shown here c. 1911, and its office at 65 High Street. The business offered piano and furniture moving and provided storage vaults.

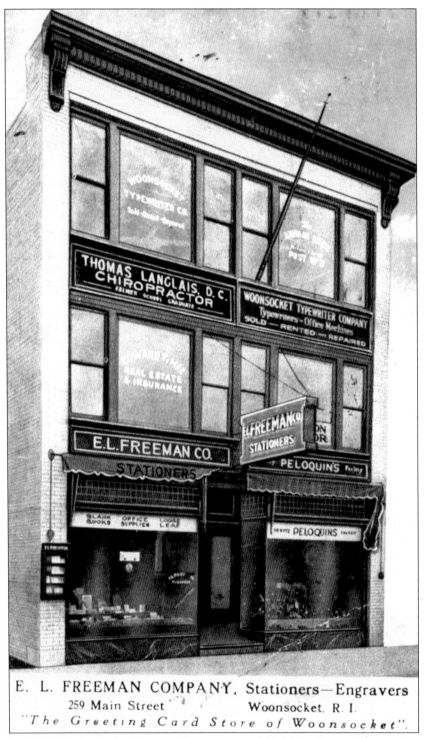

Pictured c. 1929 is the E. L. Freeman Company, at 259 Main Street. The stationery and engraving company boasted that it was "the greeting card store of Woonsocket." In addition to its publishing activities, the business also sold paper, ink, pens, and other writing materials.

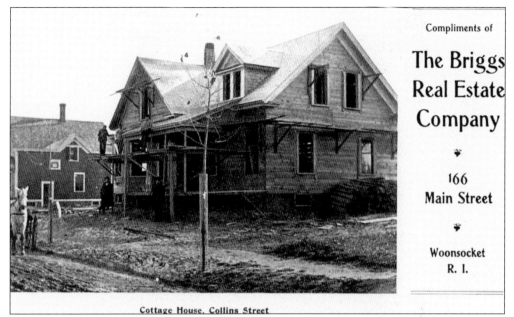

Here is a c. 1900 advertising card from the Briggs Real Estate Company, of 166 Main Street, announcing new cottage houses on Collins Street. The company constructed several small houses, usually of one story.

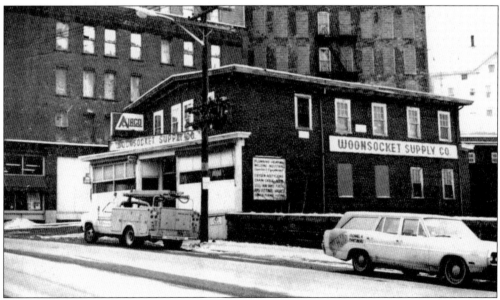

Woonsocket Supply Company, at 125 South Main Street, is shown c. 1960. Considered the city's oldest business still in operation, it advertises "everything for the welder, gas and arc." The company has a complete line of welding and cutting outfits along with arc welding accessories and electrodes. The business also carries electric and gasoline welding machines, and offers sales, repairs, and service.

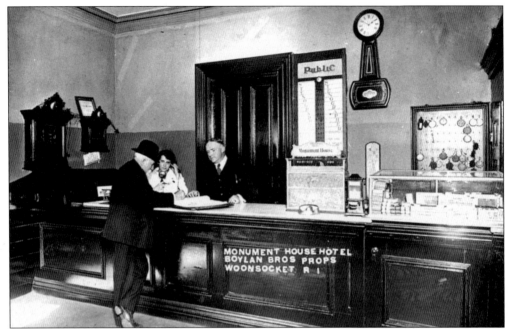

Shown c. 1920 is the main desk of the Monument House Hotel, on Monument Square. The Boylan brothers were the proprietors at this time. Their establishment provided several bedrooms, baths, and usually food for the accommodation of travelers. This structure was torn down during the 1920s to make way for the four-story Brown-Carroll Building.

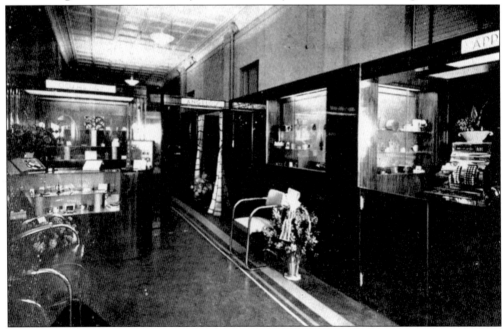

Angelo's Exclusive Beauty Salon, at 249 Main Street, is pictured c. 1954 during the beautician's 25th anniversary celebration. Angelo advertised his "new Beauty Salon" as being "centrally located for convenience," and "furnished for every facility of the profession, even to the latest equipment of approved scientific design allowing prompt and better service to ever increasing patronage."

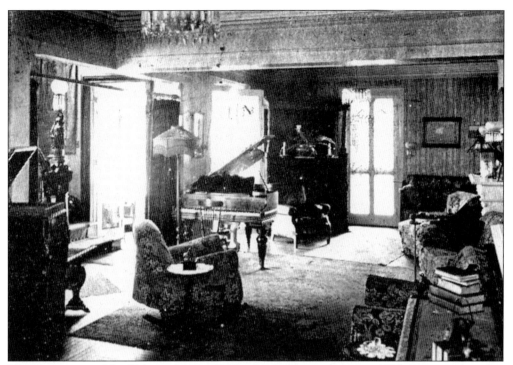
The living room of the Halcyon Inn, at 73 Hamlet Avenue, is shown c. 1925. Guests gathered in this room, which was furnished with sofas and chairs for conversation, reading, or entertainment.

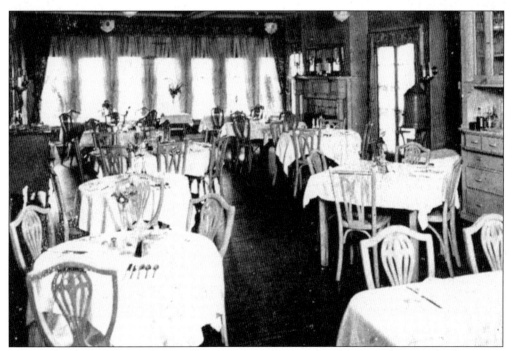
This is the dining room of the Halcyon Inn, at 73 Hamlet Avenue, photographed c. 1925. Guests gathered in this room to eat their meals, especially dinner.

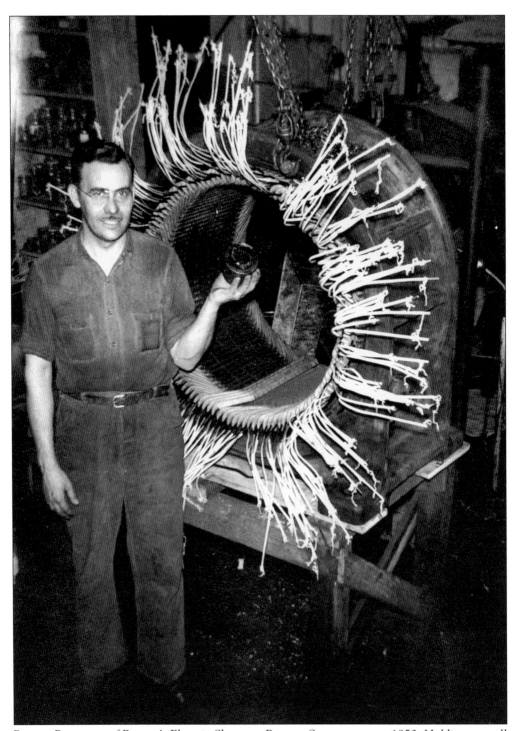

Romeo Brousseau of Romeo's Electric Shop, on Bernon Street, poses c. 1950. Holding a small motor drive, Brousseau is standing next to the largest industrial electric motor that he ever rewired. Romeo's serviced everything from small appliance motors to large industrial apparatuses. (Collection of Robert R. Bellerose.)

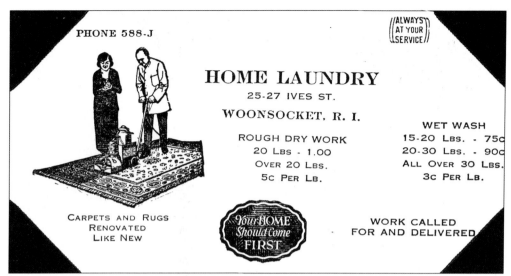

This ink blotter was issued by Home Laundry, of 25–27 Ives Street, c. 1920. Besides offering a pickup and delivery service for the laundering of clothes, Home Laundry operated a rug- and carpet-cleaning service. Notice the prices for the wash service.

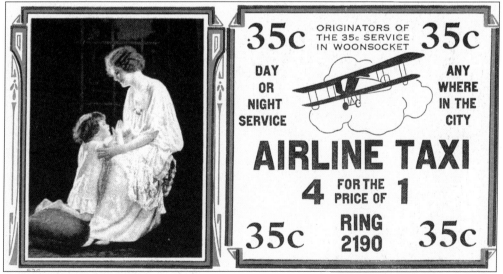

The Airline Taxi service used ink blotters as a form of advertisement. This c. 1929 advertisement announces that the taxi company originated "the 35 cents service in Woonsocket." The company was headquartered at 323 High Street. In that era, a patron could "ring up" a ride by simply asking for 2190, rather than having to dial long strings of numbers as telephone users do today.

This is a c. 1930 ink blotter advertisement from the T. J. Mee Coal Company, which operated at 9 West Street. The advertisement and the one below it are announcing anthracite coal from the Jeddo-Highland Coal Company in Pennsylvania. These are wonderful examples of Art Deco–style advertising.

Here is another c. 1930 ink blotter advertisement from the T. J. Mee Coal Company. Issued in July, this advertisement extols the benefits of purchasing coal supply during the summer months, when prices are lower and supplies are plentiful. Anthracite is a hard coal that produces much heat and little smoke.

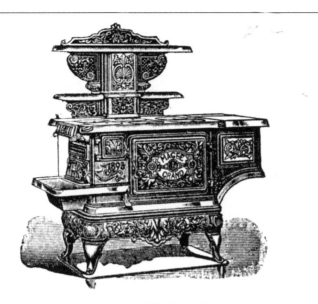

THE MAGEE GRAND.

OUR competitors confess, and the trade acknowledge, that this surpasses any first class family range on the market, uniting with great beauty of design and proportion the highest finish of Castings. The sheet flue ensures unequalled baking qualities, with the least possible consumption of fuel; it has the most perfect system of oven ventilation, the improved Magee regulator, with shelf attachment, and the unequalled Dockash grate, so adjusted that it can be easily removed without disturbing the linings. These, with the detachable shelves, automatic oven rack, and large convenient ashpan, comprise some of the features which contribute to give to this range the very first place. A careful examination will fully confirm our statement of its merits.

Send, or apply to our agents for fully illustrated circular.

MAGEE FURNACE CO.,

32 to 38 Union Street.
19 to 27 Friend Street,
 BOSTON, MASS.

242 Water Street,
 NEW YORK.
86 Lake Street,
 CHICAGO.

For Sale by WEEKS FURNITURE CO.,
LARGEST HOUSE FURNISHING STORE IN THE CITY,
48 No. Main St., (just below Opera House,) Woonsocket, R. I.

This trade card from 1893 advertises the wonders of the "Magee Grand" stove. The stove was used not only for cooking but also for heating a room. The Weeks Furniture Company, at 48 North Main Street, "just below the Opera House," had the Magee Furnace Company franchise in Woonsocket. The Weeks Company boasted that it was the "largest house furnishing store in the city."

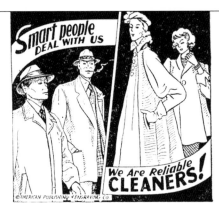

CLOTHES MAKE THE MAN OR WOMAN

We are experienced in changing old things into new. Cleaning and pressing may save you the cost of a new suit or dress.

Send it here for satisfactory results.

Spotless System Cleaners
CLEANING — DYEING — RUGS
Pick-up and Delivery Service
POplar 2-5300

145 SOUTH MAIN STREET **WOONSOCKET, R. I.**

An interesting form of an advertisement was the blotting paper given to customers by businesses. When fountain pens were popular, blotting paper—a thick, soft, absorbent paper—was applied to the written-on surface to absorb the excess ink. This c. 1940 advertisement is for Spotless System Cleaners, at 145 South Main Street.

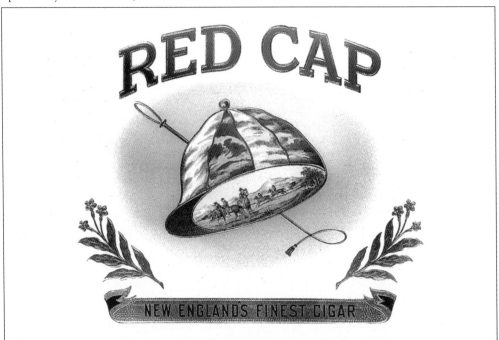

This is a label for a cigar box announcing "Red Cap, New England's Finest Cigar," c. 1940. The A. J. Breton Cigar Company, which operated at 36 Pine Street during the 1940s, manufactured these compact cigars.

Three
THE CHANGING LANDSCAPE OF WOONSOCKET

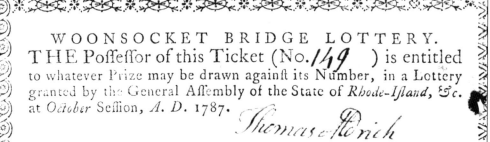

Here is a very rare Woonsocket Bridge Lottery ticket. It is ticket No. 149 and belonged to Elisha Mowry. It entitled the possessor to whatever prize might be drawn against its number. The General Assembly of the State of Rhode Island granted permission for this lottery at its October session in 1787. Thomas Aldrich administered the lottery. A total of £900 was collected for the intention of building a bridge at Woonsocket Falls. This was going to be the third bridge over the Blackstone River at this spot.

State of Rhode Island and Providence Plantations.

PROVIDENCE, SC.

City Clerk's Office, Wooonsocket, R. I., April 29 1899.

License No. 488

Pursuant to the laws of said State, License is hereby granted to *A. J. McConnell* to keep a —male Dog from the date hereof until the first day of June, A. D. 1900, which Dog is duly registered in this Office and numbered 488 and described as follows:

Yellow mongrel named Lee

Wm C Mason, City Clerk.

A. J. McConnell received license No. 488 on April 29, 1899, to keep a male dog until the first day of June 1900. This document issued by William Mason, city clerk, says that McConnell has permission to keep a "yellow mongrel named Lee."

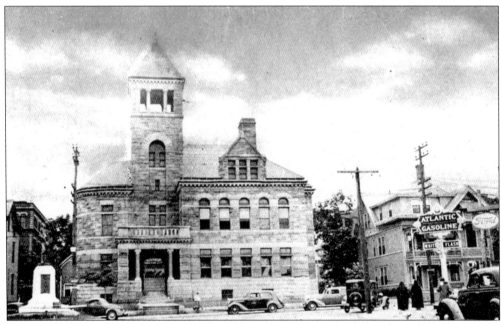

This c. 1930 view shows the courthouse, at Court Square. On the left is the Hiker Monument, erected in 1925, which serves as the city's Spanish-American War monument. On the right, where a sign announces Atlantic gasoline, a Donut Express shop stands today. The courthouse, built in 1896, served the Rhode Island Superior, Family, and District Court system. It was designed by William Walker to be "bold and ruggedly handsome" with particularly fine polychrome stonework. The structure no longer serves as a courthouse.

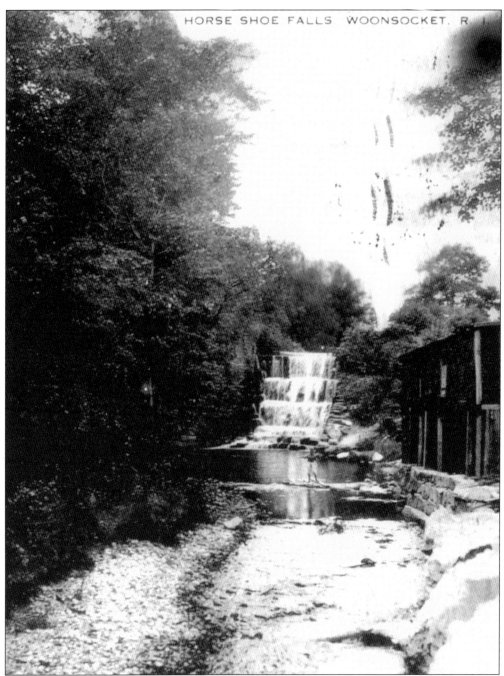

This view of Horseshoe Falls was taken from Privilege Street c. 1940. By 1860, Edward Harris, who had four woolen mills in the Market Square area, began to formulate his biggest venture: construction of a mill complex in the Privilege Street area, which would need an ample supply of water to power the machinery. To achieve this goal, Harris built a horseshoe-shaped dam on the Mill River, resulting in the formation of Harris Pond. The earthen embankments on both sides of the dam were breached before 9:00 p.m. on the night of August 19, 1955. The surging waters rushed into the center of the Social District.

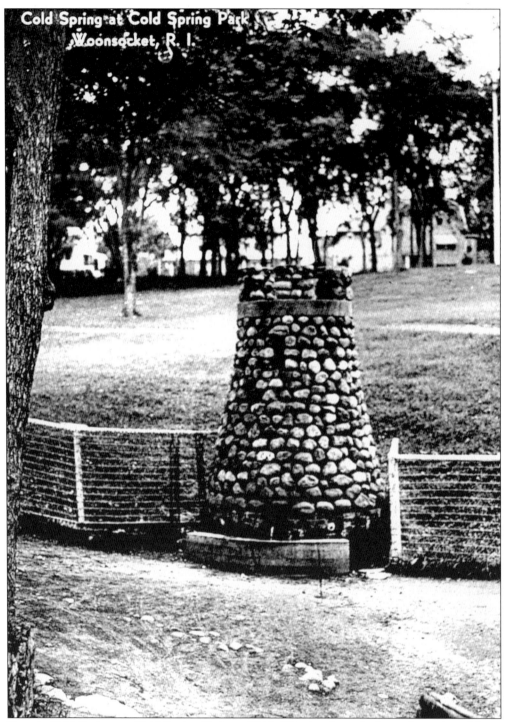

Here is Cold Spring, at Cold Spring Park, c. 1940. This lovely park slopes down from Harris Avenue to the Blackstone River. The area has been a site of leisure at least since the early 1840s, when the supporters of a liberalized state constitution, identified as Dorrites, held huge clambakes here.

Pictured c. 1919 is the Hotel Normandie. Also known locally as the Brouillard Hotel, it was located at 19–25 Cumberland Street. Herman L. Brouillard was the proprietor. This structure is no longer standing.

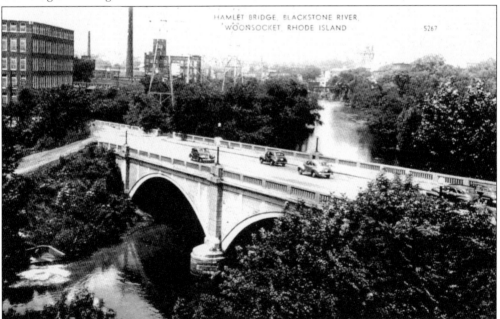

Shown is Hamlet Avenue Bridge, spanning the Blackstone River, c. 1940. This structure, which dates from c. 1900, was washed out in the flood of 1955. In 1958, a new, realigned bridge of steel and concrete replaced the fallen structure.

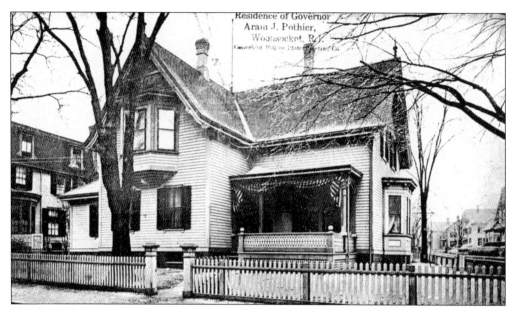

The former home of Gov. Aram J. Pothier is pictured in 1909. The Pothier House, constructed c. 1881, was the home of Jules Pothier, a shoemaker, and his son, Aram Pothier. The younger Pothier was the first French Canadian to attain a significant position in Rhode Island politics and was ultimately elected to seven terms as governor of the state. Aram Pothier's greatest distinction locally, apart from being the city's first French Canadian mayor, was in his role as a promoter of regional industrial expansion. He primarily encouraged European textile manufacturers to invest in Woonsocket, which caused a revitalization in the city's status as an affluent community, experienced primarily in the 1890s and early 1900s.

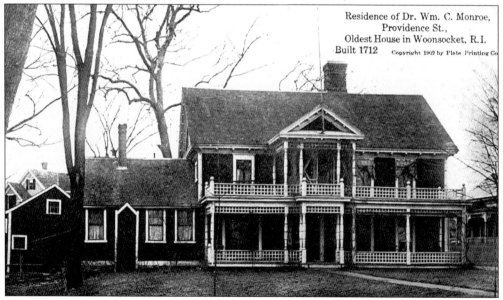

Shown in 1909 is Woonsocket's oldest structure, the former home of Dr. William C. Monroe, on Providence Street. Originally the John Arnold House, it was built in 1712 on a farm that encompassed much of this area of Woonsocket. It was the second house of John Arnold, the city's earliest Colonial settler.

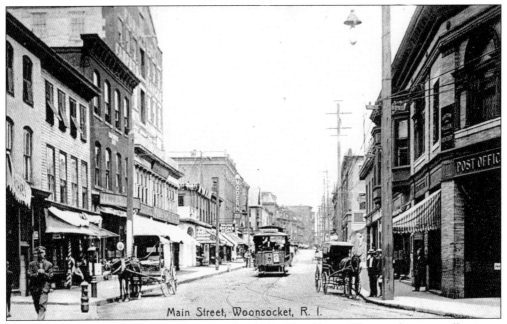

Main Street near Market Square is pictured c. 1910. The former Woonsocket post office is on the right, and the Modern Shoe Store is in the left distance. Most of the structures on either side of the street are no longer standing. This photograph and those that follow provide a view through the years of Main Street from Market Square through Depot Square and on to Monument Square.

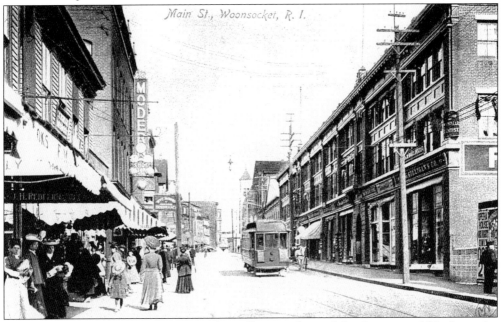

This is a c. 1910 view of Main Street. The trolley is in front of the Commercial Block, on the right, a three-level brick shop and office dating to 1902. The structure once had an elaborate, brass-embellished hydraulic elevator. On the left is the Modern Shoe Store, a fixture in Woonsocket for countless years.

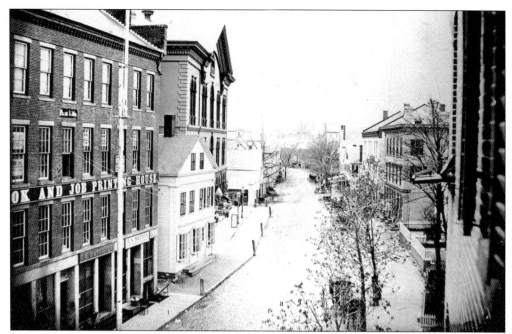

Here is Main Street in 1860. This scene is almost unrecognizable today. On the left is the Patriot Building, home to the *Woonsocket Patriot,* the city's first newspaper, which began publication in 1833. The building is no longer standing. Also on the left is the Harris Block, Woonsocket's first major commercial structure, which was built by Edward Harris in 1856. Besides its mercantile space, the Harris Block housed a library and an assembly hall, in which Abraham Lincoln spoke in 1860. Today, this structure is part of city hall. The buildings on the right are no longer standing.

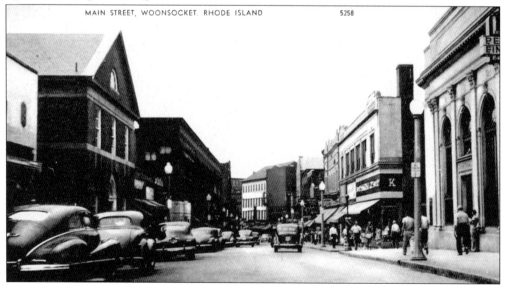

This photograph of Main Street was taken looking toward Market Square c. 1940. On the left is the Old Colony Cooperative Bank and the Commercial Building, a three-level brick shop and office structure built in 1902. On the right is the Woonsocket Institution for Savings building and S. S. Kresge, a five-and-ten.

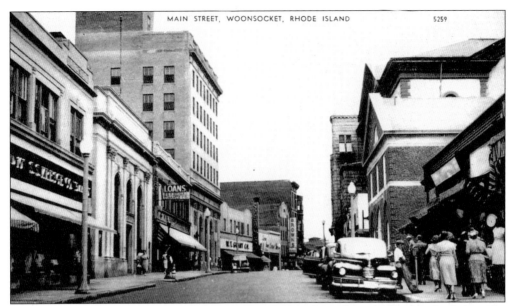

This scene is similar to the one below except that it dates from 1940. On the left is the former S. S. Kresge department store, built c. 1923. Along that side of the street are the former Woonsocket Institution for Savings, built in 1926, and the Rhode Island Hospital Trust Building, built in 1929. W. T. Grant Company, Spencer Shops, Lerner Shops, and Joseph Brown Drug Store can also be seen. On the right is the Old Colony Cooperative Bank, built in 1937. The Harris Block and city hall are also visible.

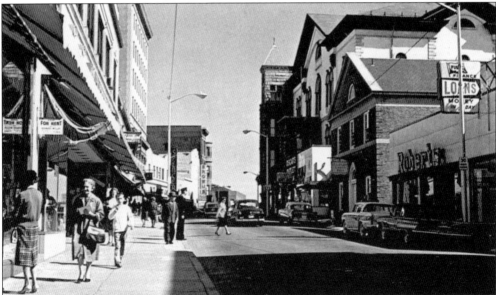

Main Street in the industrial hub of northern Rhode Island is pictured c. 1960. Many people may remember this scene. Robert's Children's Shop, established in 1925 by Robert Levine, is on the right. The Old Colony Bank is next door. The street-level shops of the Harris Block, next to the bank, include Kay and Oscar's Outlet. City hall, built in 1891, is on the far right. Joseph Brown Drug Store, which opened in 1881, is in the distance. Spencer Shops, W. T. Grant, and the Rhode Island Hospital Trust, are on the left.

City hall stands on Main Street c. 1900. Built in 1891, it is a rugged, granite-clad structure of the Richardsonian Romanesque style. The Harris Block, built in 1856, is barely visible on the right. The structure on the left was torn down in the 1970s, and the space was incorporated into the Main Street Mini-Park.

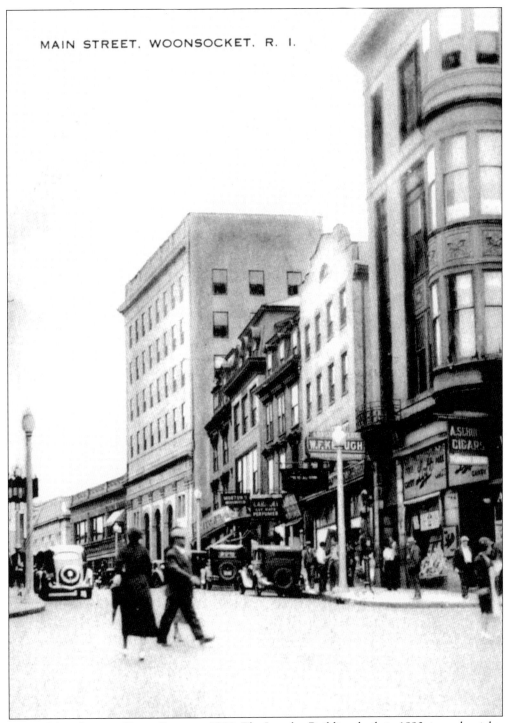

Here is Main Street at Depot Square c. 1930. The Longley Building, built in 1890, is on the right. This four-level brick block, with its bulging bay windows, still stands today. Also, on the right are the buildings housing W. F. Keough, Carroll Cut Rate Perfumer, and Morton's, all of which were demolished in later years. Today, this space serves as a parking lot for automobiles.

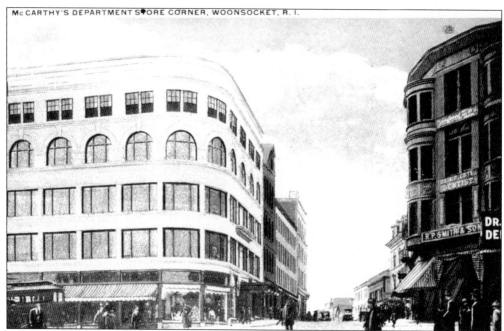

This scene is of McCarthy's at Depot Square c. 1923. McCarthy Dry Goods Company was founded in 1889. In 1914, James M. McCarthy unveiled a new six-floor department store at Depot Square, which highlighted 45 specialty departments. In the 1960s, McCarthy's relocated to Walnut Hill Plaza.

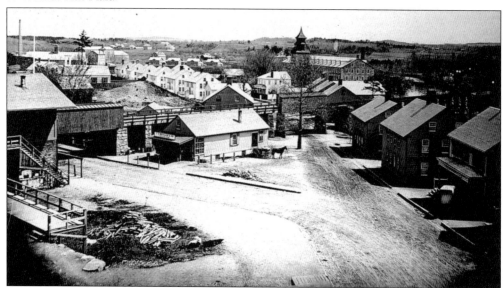

Depot Square is pictured in 1860. With considerable changes, it later became Flynn Square, in honor of Lt. Harold F. Flynn, who died in World War I. Woonsocket's first train depot, built in 1847, is on the left. In 1882, an elaborately embellished brick structure designed by John W. Ellis replaced the original depot. The Hope Building, built c. 1876 and today the home of Family Resources, replaced the T. C. Boyland Company store, seen in the center. The tenement houses on the right are the approximate locations for the Unity Building, the Clinton Street Market, and the Blackstone Hotel. In the distance is the Clinton Mill.

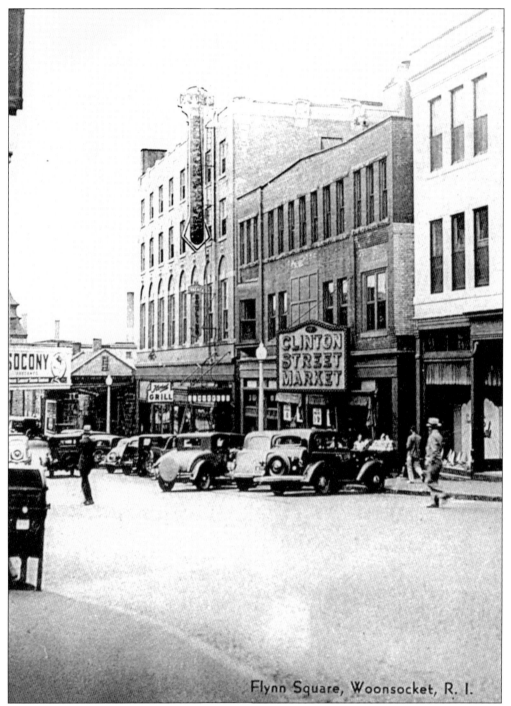

Flynn Square is pictured c. 1930. On the extreme right is part of the Unity Building, built c. 1886. This three-level brick office block housed the Union St. Jean Baptiste Society until 1926 and then the offices of Blackstone Valley Gas and Electric Company. The Clinton Street Market, located next-door, met the wrecking ball in later years, and the space became a parking lot. Farther down Clinton Street is the Blackstone Hotel.

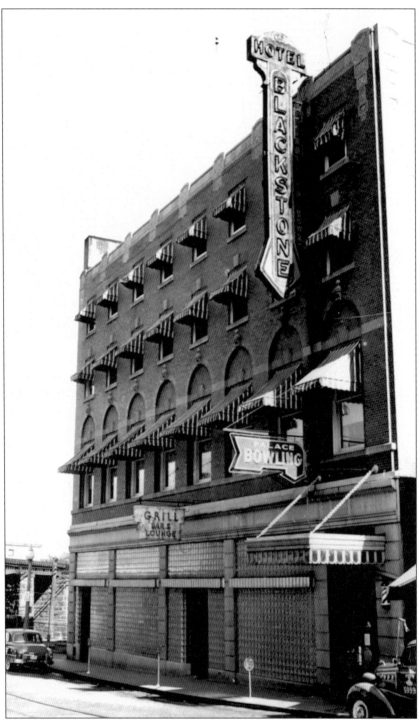

The Blackstone Hotel is shown c. 1950. Built in the late 1920s, it was a four-level, opulent, fireproof hotel. It boasted 50 rooms, including a grand ballroom on the second floor. The street level had room for four businesses and a small barbershop. The Palace Bowling Alleys occupied the basement. Today known as the Dreyfus Building, this structure serves as an apartment complex.

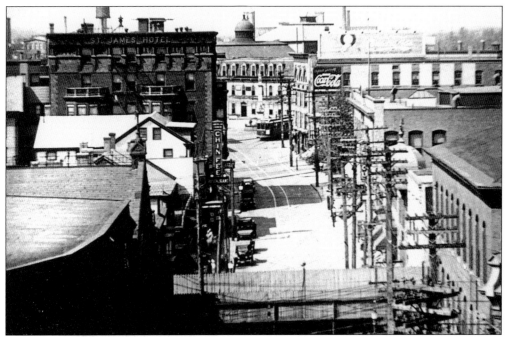

This photograph of Main Street was taken looking toward Monument Square c. 1920. In the foreground are the railroad tracks that go over Main Street, with the railroad depot immediately on the left. The former Bijou Theatre's dome is on the right. The former Chin Fee Restaurant is on the left, with the old St. James Hotel in the distance. Built in 1892, the St. James was the city's major hotel until November 1986, when a fire ravaged this Main Street landmark.

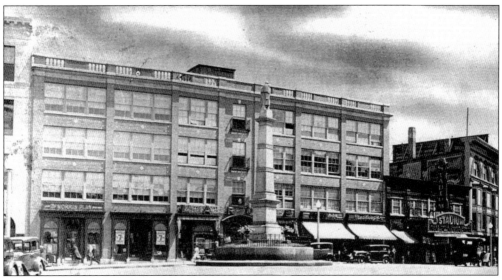

In this c. 1935 view of Monument Square, the Civil War Monument is in the center, with the Stadium Building and Theatre in the background. Conceived by J. G. Batterson of Hartford and erected in 1870, the monument was the earliest Civil War memorial built in Rhode Island. The Stadium Office Building and Theatre were part of a theater-store-office structure built by Arthur Darman in 1926. Today, the theater is home to the Stadium Theatre Performing Arts Center.

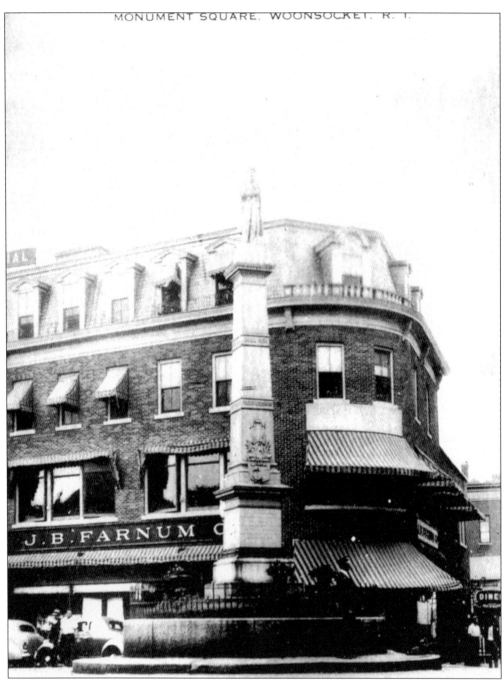

Monument Square is shown c. 1940. The Brown-Carroll Building, in the background, was constructed on the site of an old familiar site at Monument Square: the Monument House. The new structure, built in the late 1920s, was constructed by William J. Brown and George W. Carroll at a cost of more than $150,000. It was to accommodate the J. B. Farnum Company, one of Woonsocket's most important paint and hardware establishments, and sets of rooms that came to be identified as the Colonial Hotel. The building was destroyed in a massive fire on September 22, 1975.

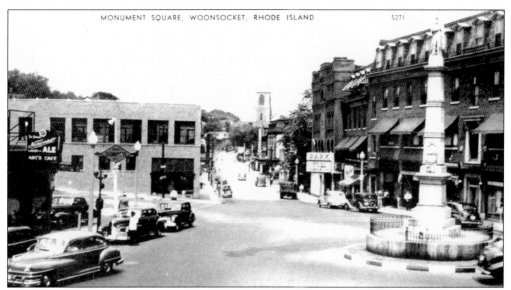

Monument Square is pictured c. 1940. The view is looking up North Main Street, with the tower of St. Charles Church in the distance. On the left is the former Montgomery Ward Building, constructed in 1929 and now home to the Salvation Army. Across the street is the entrance to the Park Theater, housed in the former Woonsocket Opera House, and on the right side is the Brown-Carroll Building. This Civil War Monument, erected in 1870, has carved on it the names of battles in which Woonsocket men took part.

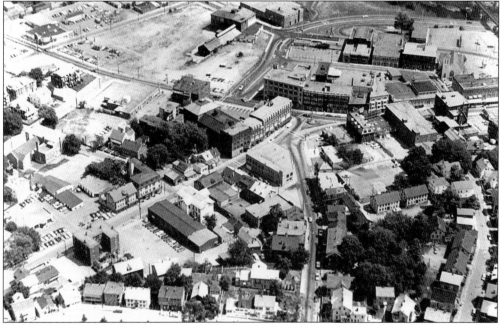

This aerial view of the Monument Square area was photographed c. 1970. Of particular note are the old Woonsocket Opera House and the neighboring Brown-Carroll Building, in the center. On September 22, 1975, a fire of suspicious origin destroyed these two buildings. The vacant lot in the upper left corner was the location of the American-Wringer Company factory. Today, this space is the site of a U.S. post office and the headquarters of the Woonsocket Police Department.

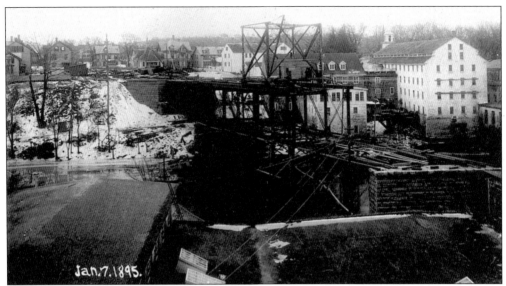

This view of the construction of the Court Street Bridge dates from January 7, 1895. The mill buildings on the right are the former Woonsocket Company mills, situated along Front Street. Construction started from the Hamlet Avenue end in 1893 and was completed in June 1895. The bridge cost more than $300,000 and used 100,000 rivets and 40,000 bolts in its construction.

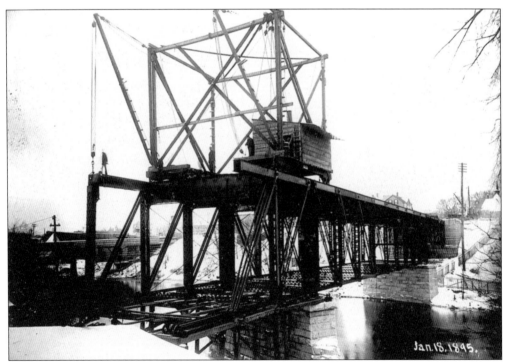

Seen is a January 18, 1895, view of the construction of the Court Street Bridge. The bridge was dedicated on June 22, 1895. Some 15,000 bystanders at the dedication ceremonies beheld a parade, band music, and speeches. Just over 100 years later, this scene was duplicated when a new bridge replaced this structure.

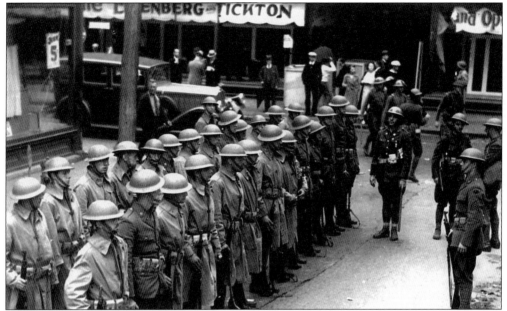

National Guard troops receive orders at the corner of Clinton and Cumberland Streets during the Great Textile Strike of 1934. On September 1, 1934, a nationwide walkout of textile workers was called by the the United Textile Workers. On the night of September 11, 1934, a mob of some 2,000 tried to shut down the Rayon Company mill on Clinton Street by shattering windows and showering the factory with rocks. National Guardsmen were called out to establish order in Woonsocket.

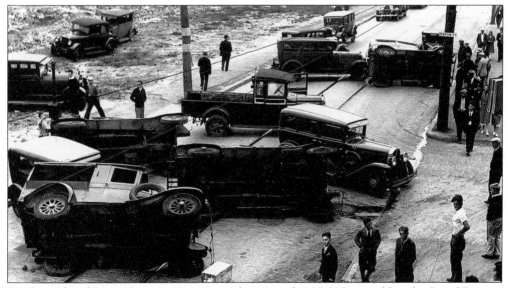

On the night of September 12, 1934, a crowd estimated at 10,000 ran wild in the Social District of the city. Although confined by the entire Woonsocket police force to an area along Clinton Street between Worrall and Cumberland Streets, rioters swung into action once darkness arrived. They hurled rocks at the police, smashed street lamps and store lights, overturned parked cars, and looted. This scene, at the corner of Social and Sampson Streets, shows some of the devastation.

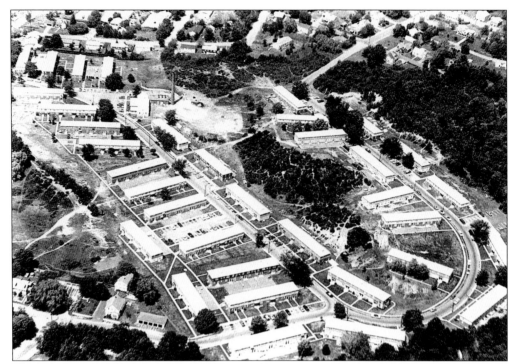

This aerial view of the Morin Heights Housing Project was taken c. 1970. The Morin Heights Housing Project, which accepted its first residents in December 1942, was a project created under the Works Progress Administration. This federal bureau, created by Franklin Delano Roosevelt, helped to generate jobs for the unemployed during the Great Depression.

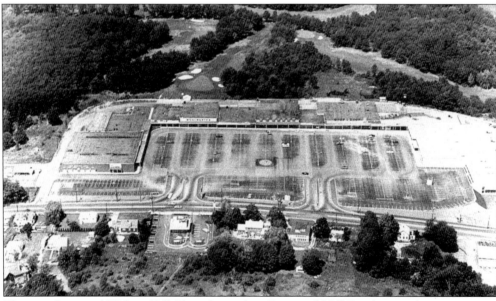

This aerial view of Walnut Hill Plaza, located on Diamond Hill Road, was taken c. 1970. In 1959, the Ferland Corporation started construction of Walnut Hill Plaza. When it opened in early 1960, this 15-acre site became Woonsocket's first shopping plaza. Early tenants included Sears, Woolworth's, W. T. Grant, Stop & Shop, and a Rexall drugstore.

Four
THE WOONSOCKET RUBBER COMPANY'S ALICE MILL

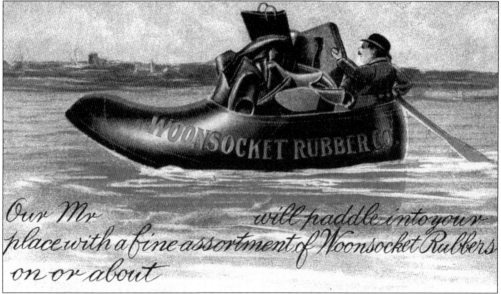

This card from 1907 was used by sales agents of the Woonsocket Rubber Company. Mailed to retail establishments, the card announced the company's arrival with samples of boots and assorted rubber footwear for sale. Used in making visits, these small cards displayed one's name and corporate affiliation.

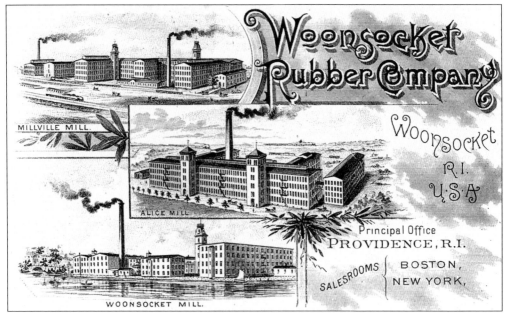

This c. 1900 view depicts the three principal mills of the Woonsocket Rubber Company. The company, founded by Joseph Banigan, had its start at Market Square in Woonsocket during the mid-19th century and built the crown jewel of its empire in 1889. That year, the corporation bought a 20-acre lot on Buffum's Island in Fairmount and began construction of the Alice Mill. Built of brick resting on a granite base, this enormous mill is four stories high.

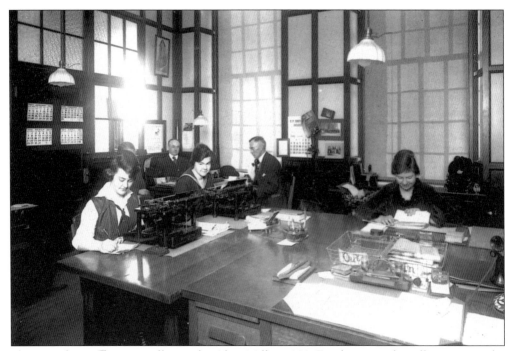

Shown is the employment office at the Alice Mill c. 1920. Employees at this office oversaw the employment records of all the workers at the mill.

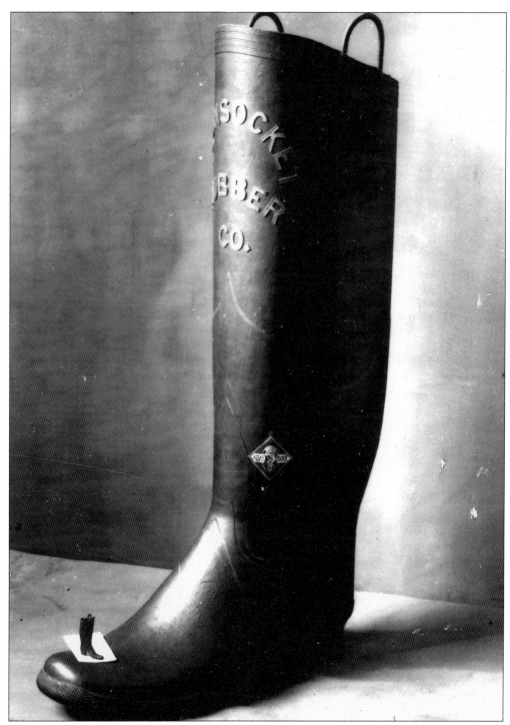

Shown is a rubber boot made at the Alice Mill c. 1920. Before the use of synthetically produced rubber, boots made in this factory used an elastic substance produced from the milky sap, called latex, of various tropical plants. After being treated by vulcanization, the crude rubber was ready for the making of footwear.

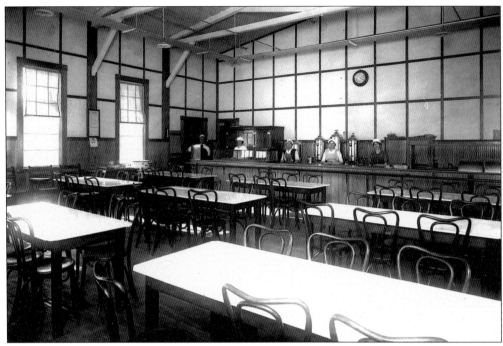

The restaurant within the Alice Mill is shown c. 1920. The Woonsocket Rubber Company offered this place in which employees could purchase meals.

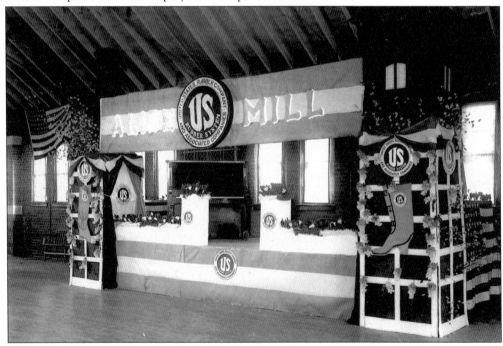

At the armory on Arnold Street, the orchestra stand is shown decorated for the Alice Mill c. 1920. A division of the United States Rubber Company, the Woonsocket Rubber Company often sponsored dances and employee-recognition events at various locations in the city over the years.

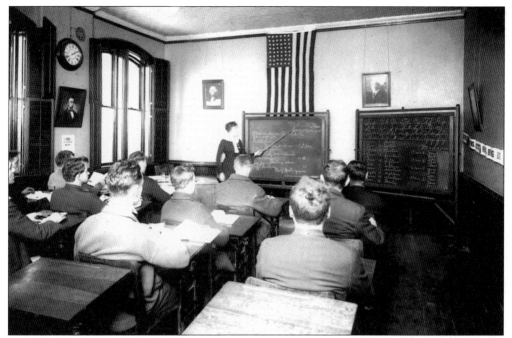

Shown is the Americanization school within the Alice Mill c. 1920. The school held classes where mill employees learned about the character, manners, methods, and ideals of the United States. The sessions were aimed at helping the students assimilate American customs, speech, and so on.

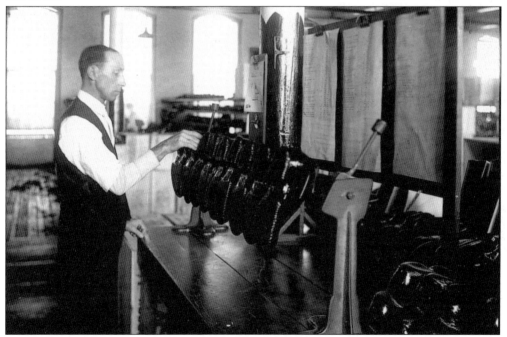

An employee poses with a device for stripping shoes at the Alice Mill c. 1920. The Woonsocket Rubber Company made an assortment of footwear over the years, including various styles of shoes and boots.

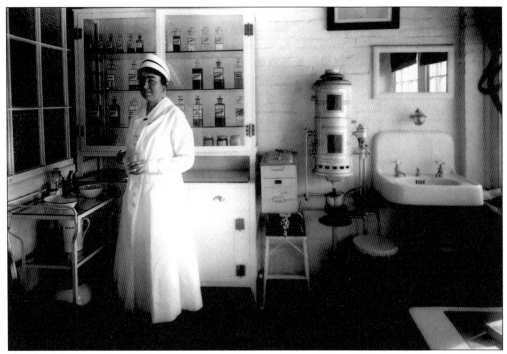

A nurse is pictured in the hospital room within the Alice Mill c. 1920. Here, the ill or injured received medical or minor surgical treatment from the nursing staff.

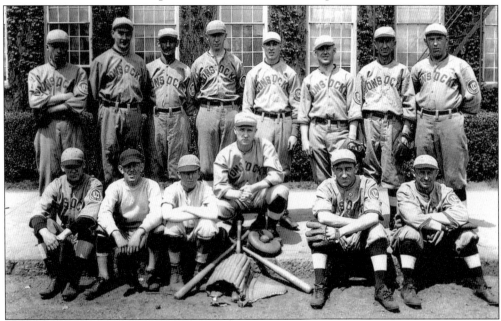

Members of the Alice Mill baseball team pose for a photograph c. 1920. During the late 19th and early 20th centuries, it was common for companies such as the Woonsocket Rubber Company to sponsor baseball teams. Besides being a source of pride among company executives, the activity provided a recreational outlet for the employees. Many a Sunday afternoon was spent at the ball field, playing and watching these spirited games.

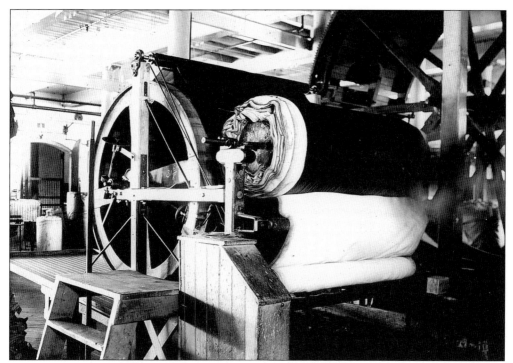

Pictured is the jersey netting drum in the cutting room of the Alice Mill c. 1920. From this supply drum came a netted material of a soft, elastic knitted cloth of wool, cotton, silk, or rayon.

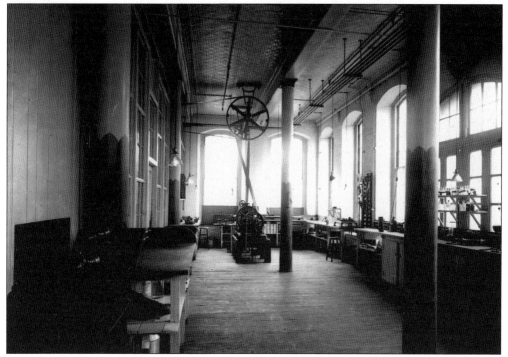

This is a laboratory within the Alice Mill c. 1920. Scientific experimentation and research were conducted in this room, as was the preparation of chemicals.

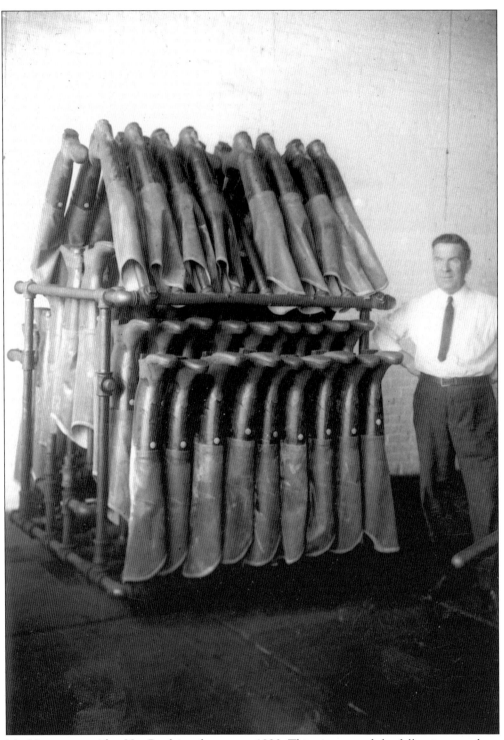

Mr. Hunt poses with a Vac Pershing shoe car c. 1920. This picture and the following one show an assortment of rubber foot products made by Woonsocket Rubber Company.

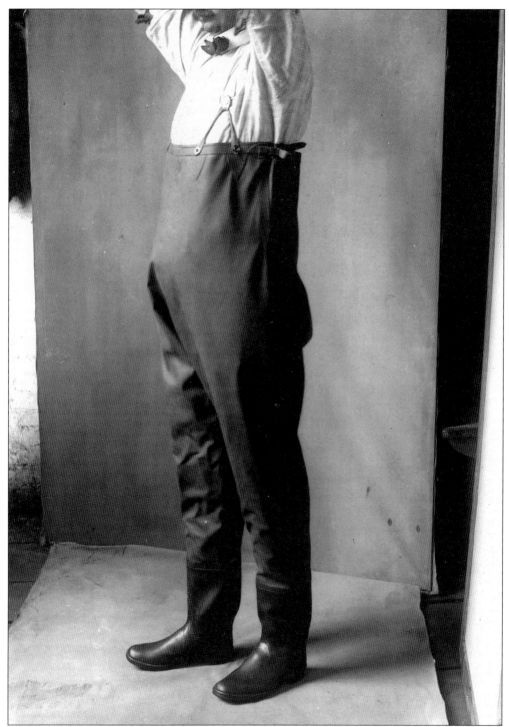

These body boots were manufactured at the Alice Mill c. 1920. At the time of its construction in 1889, the Alice Mill was the largest and most contemporary rubber footwear factory on the globe.

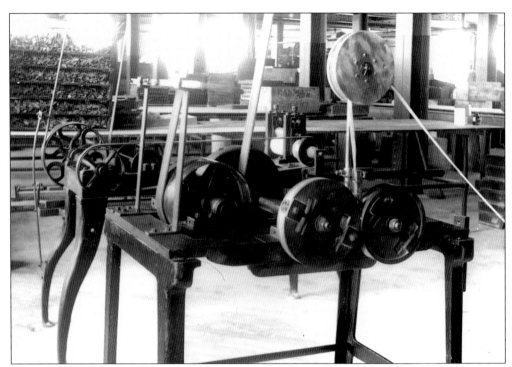

Shown is the strap-cutting-off machine at the Alice Mill c. 1920. This machine produced a leather loop for pulling on boots. The Alice Mill of the Woonsocket Rubber Company was the footwear unit of the United States Rubber Company. It was shut down from February 19 to May 9, 1921, because of a lack of orders.

This is a motivational poster that hung in the Alice Mill of the United States Rubber Company c. 1920. The Alice Mill shut down in 1932 and continued to be idle until September 1941. That month the mill reopened for the manufacture of barrage balloons and 10-man rubber assault crafts required for America's World War II endeavor.

Five
THE FLOOD AND THE HURRICANE OF 1938

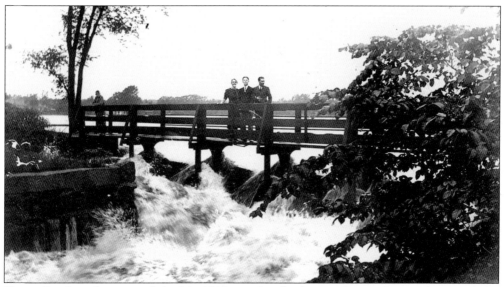

Harris Pond is shown on July 24, 1938, as the floodwaters begin their rush toward the Horseshoe Falls and eventually into the Social District of the city of Woonsocket. The dam, built by Edward Harris along the Mill River, created Harris Pond. The pond served as an abundant source of water to power Harris's Privilege Mills. At other times during torrential rains, Harris Pond was the source of floodwaters that put the Social District of Woonsocket under water.

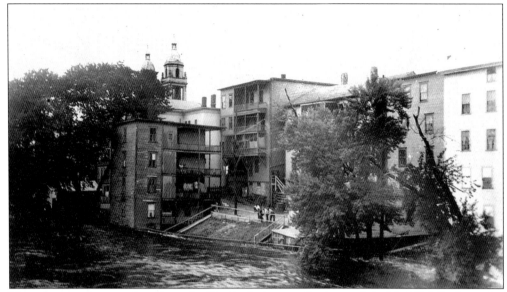

This photograph was taken from the Kendrick Avenue Bridge on July 24, 1938. It shows the floodwaters of the Blackstone River behind the tenement houses along Cumberland Street. In the distance are the twin spires of St. Ann's Church. This scene is unfamiliar today, as the tenement houses were demolished in later years.

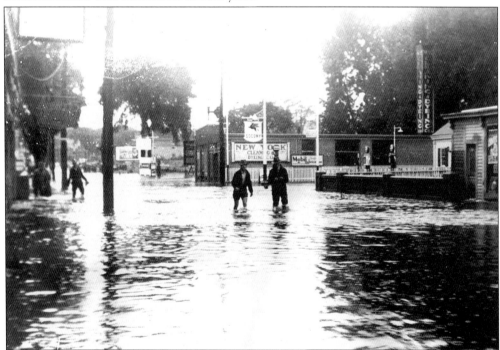

This photograph, taken on July 24, 1938, shows floodwaters along Social Street. The sign at the left is locating Sauvageau's Electric Shop. Across the street is Leduc's Gas Station and the New York Cleaning and Dyeing Shop. In the 1960s, the U.S. Army Corps of Engineers installed a flood-control project. Until then it was very common after torrential downpours for the Social District and areas along the Blackstone River to be flooded.

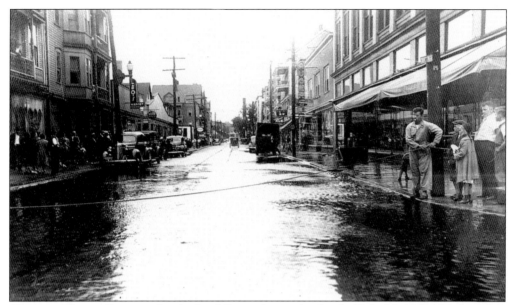

Shown is Clinton Street at Cumberland Street during the flood of July 24, 1938. On the left is the site of Leo's Market, and across the street is Auger's Furniture Store. Directly at the corner on the right is the Eisenberg and Tickton store. With so many buildings since razed, this scene is now but a memory.

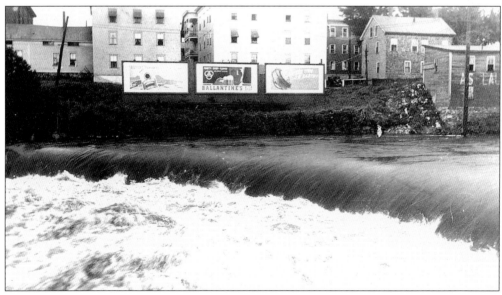

This view, taken from the Bernon Street Bridge on July 24, 1938, shows the floodwaters of the Blackstone River going over the Bernon Dam. The billboards and tenement houses on the opposite bank are on the Front Street side of the river.

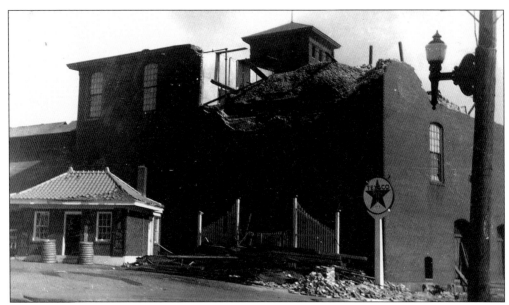

This view of the American Wringer Company was taken from the corner of Clinton and Worrall Streets after the September 21, 1938, hurricane. To this day, some historians consider the hurricane to be the most frightening and disastrous occurrence in Rhode Island's history.

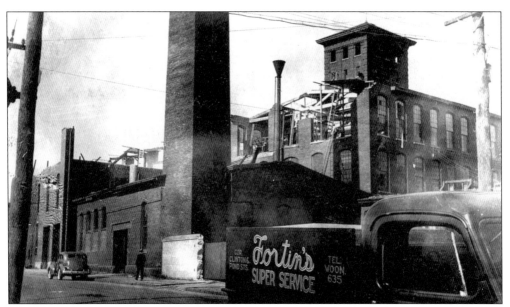

Here is another view of the American Wringer Company, photographed shortly after the 1938 hurricane. Seen from the Clinton Street side is the roof damage to the sprawling mill complex. In the foreground is a truck of the former Fortin's store, a tire dealer at the corner of Clinton and Pond Streets. This hurricane was especially destructive because the people of Rhode Island were unaware of the approaching storm and were unprepared. No technology existed in the 1930s that could have given warning of the hurricane's arrival.

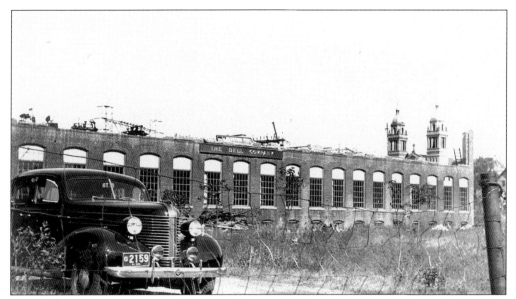

The second floor of the Bell Worsted Mill, on Villanova Street, was swept away by the gusts of the September 1938 hurricane. In the background are the twin spires of St. Ann's Church, on Cumberland Street. The photograph was taken shortly after the hurricane passed.

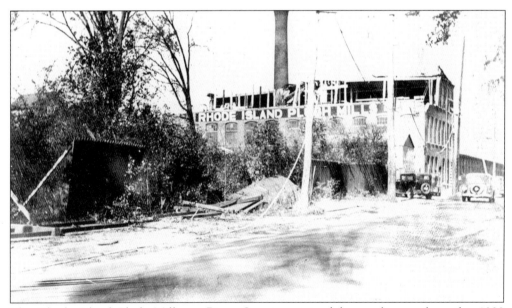

The Rhode Island Plush Mill, on River Street, sustained heavy damage from the 1938 hurricane. This photograph, taken shortly after the cleanup effort began at the end of September, shows the destructive power of one of Rhode Island's major storms.

This photograph shows some damage sustained by many of Woonsocket's tenement houses. The scene, photographed after the September 21, 1938, hurricane, is Privilege Street. Like all inland communities, Woonsocket sustained a wide path of ruin due to hurricane gusts.

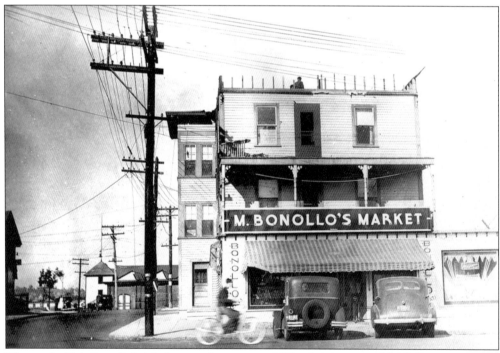

The roof of M. Bonollo's Market, at the corner of Wood Avenue and Mill Street, received heavy damage from the 1938 hurricane. In Woonsocket, the force of the storm caused windowpanes to break in many homes and commercial display windows to become shards of flying glass.

Even the massive statue of the patron saint of St. Ann's Church could not withstand the violent winds of the 1938 hurricane. The church building, on Cumberland Street, along with many other Woonsocket structures, had its windowpanes coated with sea salt from the strong winds.

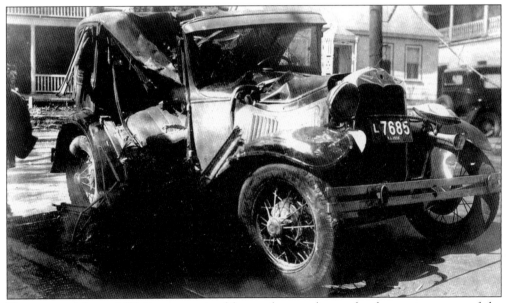

This automobile on Mill Street sustained heavy damage due to the destructive power of the 1938 hurricane. The photograph was taken shortly after the hurricane passed.

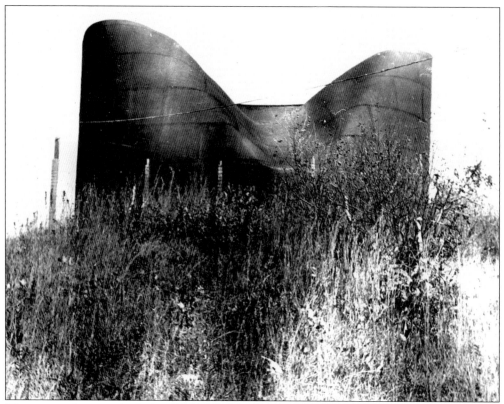

This scene, photographed after the hurricane of 1938, shows the damage sustained by a water tank atop Bernon Heights. At the peak of the hurricane, gusts reached 121 miles per hour.

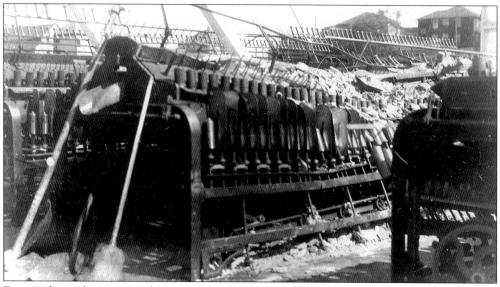

Damaged textile-spinning frames at the Onawa Mill are pictured after the hurricane of September 21, 1938. The Onawa Mill was at 767 Social Street. An assessment of Rhode Island real estate destroyed by the hurricane amounted to $100 million.

Six
THE BLACKSTONE VALLEY GAS AND ELECTRIC COMPANY

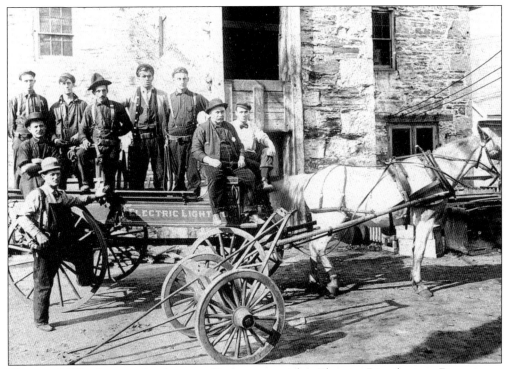

This c. 1915 photograph shows a line crew at the Electric Distribution Department headquarters, off Front Street. In 1913, the Woonsocket City Council ratified an agreement for street lighting with the new Blackstone Valley Gas and Electric Company. The city held a White Way festival on May 14, 1914, after the firm positioned 39 new electrical lights on Main Street. Shops, adorned with festive decorations, opened at dusk following a band parade.

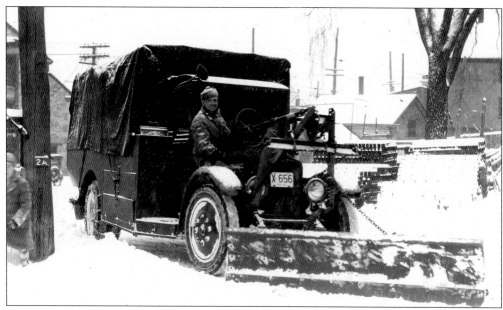

An unidentified Blackstone Valley Gas and Electric Company employee operates a snowplow attached to a truck on January 15, 1929. The scene is at the Electric Distribution Department headquarters, off Front Street. (Collection of Robert R. Bellerose.)

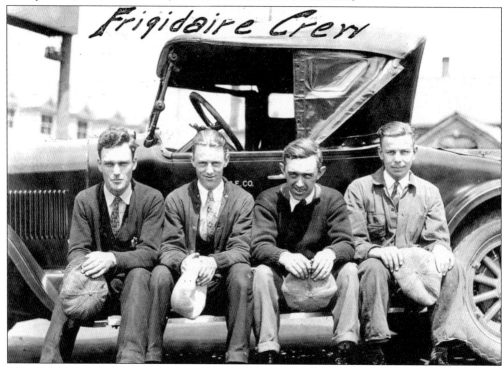

The Frigidaire crew poses for a photograph at the Electric Distribution Department headquarters, off Front Street, c. 1930. The names are listed as Mert, John, Bill, and Louie. These employees of the Blackstone Valley Gas and Electric Company were responsible for repairs on the Frigidaire, an electric refrigerator. (Collection of Robert R. Bellerose.)

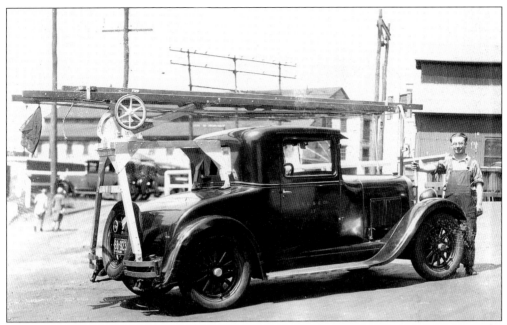

Photographed at the Electric Distribution Department, off Front Street, in June 1930 is the streetlight patrol, showing the extendable ladder in the closed position on car No. 37. This employee of the Blackstone Valley Gas and Electric Company was responsible for the identification and repair of burnt-out or damaged streetlights. (Collection of Robert R. Bellerose.)

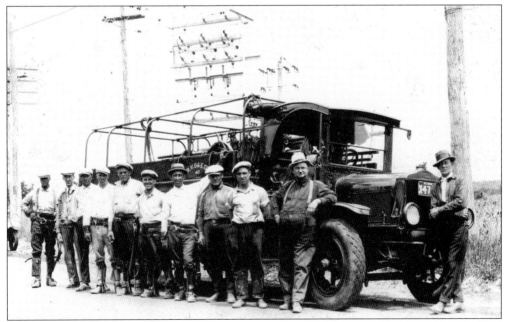

This photograph, taken c. 1938, bears the caption "The Gang that Handled Most of the Reconstruction." These employees of the Blackstone Valley Gas and Electric Company are, from left to right, A. Morrissey, F. Morin Sr., F. Morin Jr., H. Houle, J. Gagnon, J. Tellier, A. Lafferty, S. Smith, A. Morin, J. Gadon, E. Thibeault, and E. Gervais. (Collection of Robert R. Bellerose.)

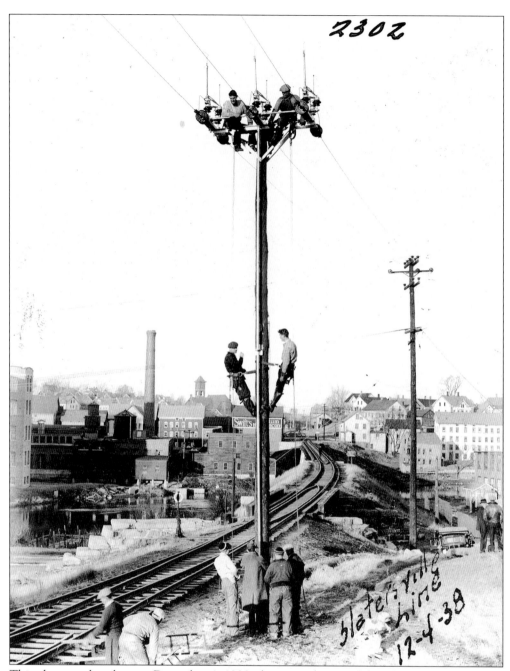

This photograph, taken on December 4, 1938, shows employees of the Blackstone Valley Gas and Electric Company working on the Slatersville Line. They are working along the rail line of the Pascoag Extension. Across the Blackstone River are the businesses and houses along River Street. In the distance is the tower of the First Baptist Church, on Blackstone Street. (Collection of Robert R. Bellerose.)

The Blackstone Valley Gas and Electric Company storm crew is pictured in October 1938 at the Electric Distribution Department headquarters, off Front Street. This crew was responsible for repairs in the Woonsocket area after Rhode Island experienced the frightening and destructive hurricane of September 21, 1938. (Collection of Robert R. Bellerose.)

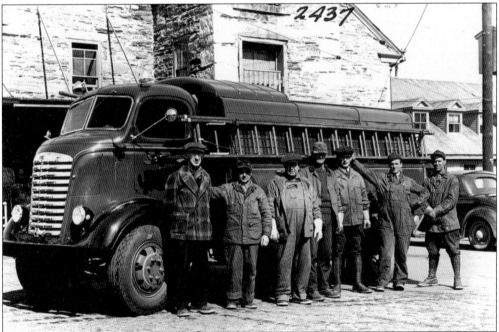

Titled "Owen's Crew," this photograph was taken on March 18, 1940, at the Electric Distribution Department headquarters, off Front Street. Shown are truck No. 53 and members of the road crew who, under the direction of a supervisor, were responsible for repairs and installations along the Blackstone Valley Gas and Electric Company's electric lines. (Collection of Robert R. Bellerose.)

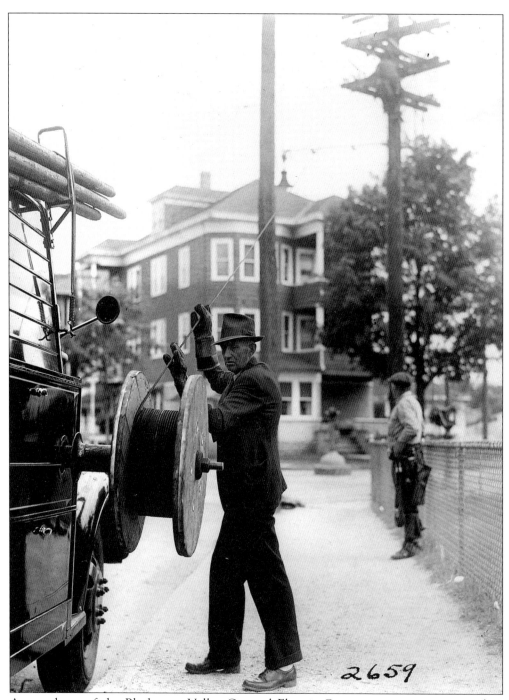
An employee of the Blackstone Valley Gas and Electric Company operates a wire-reeling device in Woonsocket on June 25, 1942. This device was used to replenish a line repairer's supply of wire from the spool. (Company photographer, collection of Robert R. Bellerose.)

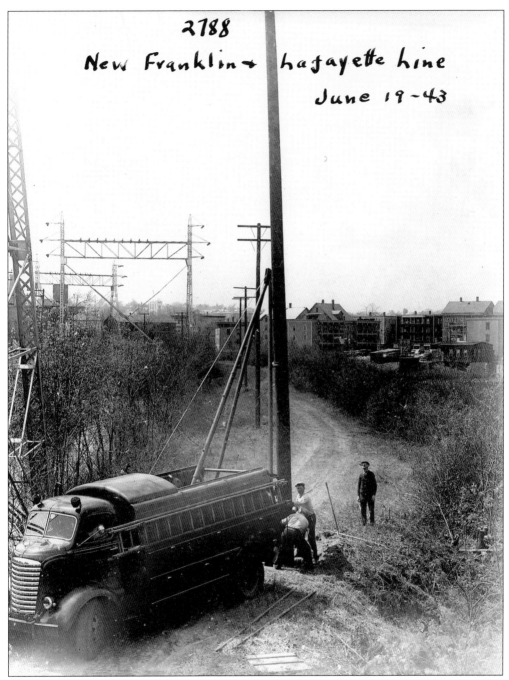

Shown is the installation of the new Franklin and Lafayette line, photographed on June 19, 1943. The Blackstone Valley Gas and Electric Company maintained several private right of ways that provided access to its electric lines. The private ways were usually old paths alongside a canal or railroad bed. (Collection of Robert R. Bellerose.)

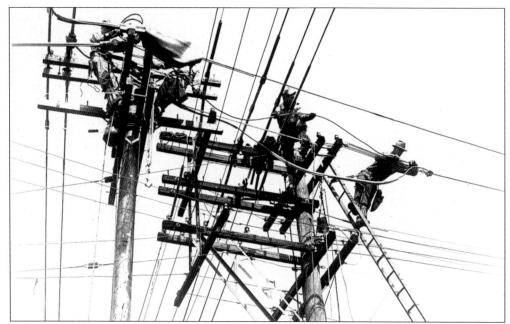

This July 1941 photograph shows Blackstone Valley Gas and Electric Company employees working on the electric lines at Page and Social Streets. The employees are identified as, from left to right, Greenan, Babineau, Vadenais, and Phillip A. Levesque. (Collection of Robert R. Bellerose.)

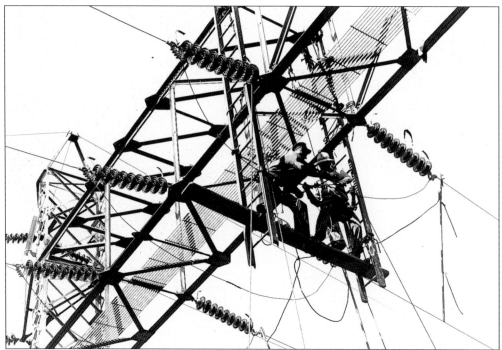

Two employees of the Blackstone Valley Gas and Electric Company, Phillip A. Levesque (left) and a Mr. Babineau, make connections under the bridge towers at Hamlet Island on September 12, 1943. (Company photographer, collection of Robert R. Bellerose.)

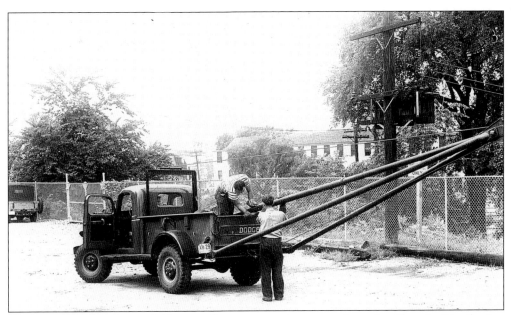

Blackstone Valley Gas and Electric Company employees work at the Electric Distribution Department headquarters, off Front Street, on September 1, 1949. They are modifying a Dodge Power Wagon to make use of a pole derrick. The derrick was for lifting and moving heavy poles. The apparatus consisted of a long, moving beam pivoted at the base of a vertical, stationary beam and guided by ropes running on pulleys. (Collection of Robert R. Bellerose.)

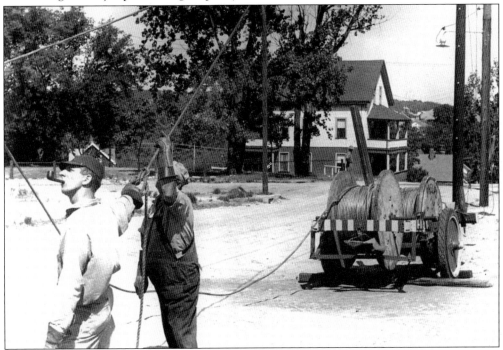

Members of a Blackstone Valley Gas and Electric Company line crew work on Vose Street in 1953. The line installer is an individual whose work involves setting up and repairing lines. (Collection of Robert R. Bellerose.)

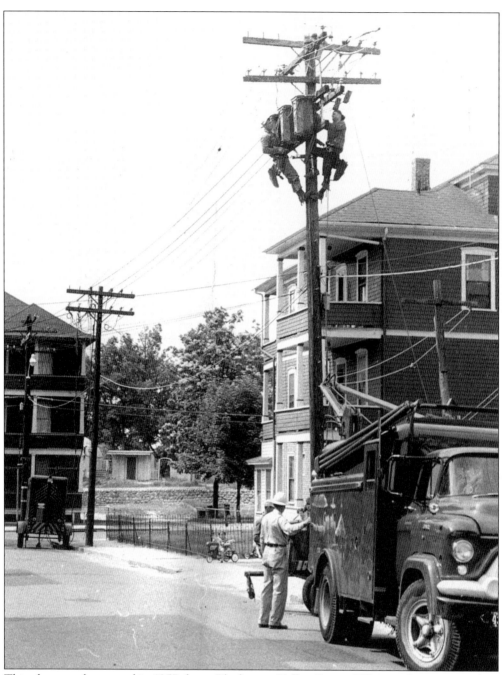

This photograph snapped in 1957 shows Blackstone Valley Gas and Electric Company workers using the transformer trailer and changing out the transformer bank on Sweet Avenue. Transformers are of two types, step-down and step-up, regulating voltage of an electric current. (Collection of Robert R. Bellerose.)

Seven
FESTIVALS, CELEBRATIONS, AND PARADES

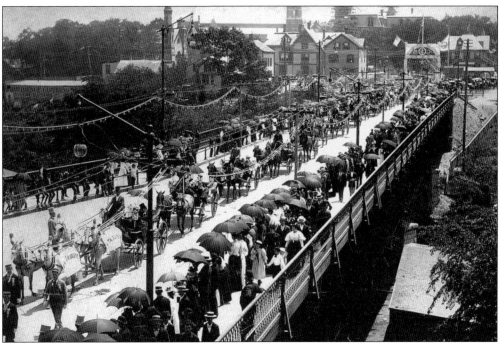

This photograph, taken on June 22, 1895, shows the parade held in celebration of the new Court Street Bridge. Some 15,000 bystanders witnessed the dedication ceremonies that included a parade, band music, and speeches. The centerpiece was a huge arch, adorned with tinted lights that formed the words "City of Woonsocket."

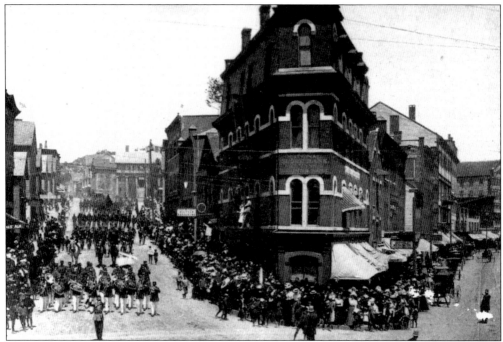

Photographed c. 1900 is a parade at the corner of Arnold and Main Streets. The marchers have left the armory, located on Arnold Street, and are heading for Harris Hall, on Main Street, to participate in a civic ceremony.

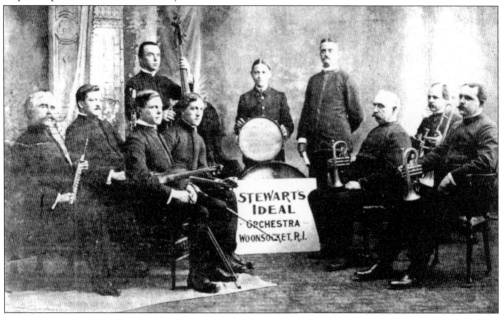

Stewart's Ideal Orchestra was a popular Woonsocket orchestra at the beginning of the 20th century. Pictured in 1906, the group consisted of 10 virtuoso players, who were accompanied by a male quartet for some musical selections. The orchestra was the musical entertainment for a grand New Year's ball at Harris Hall on Tuesday, January 1, 1907, at 8:00 p.m. Admission for the gala affair was 35¢.

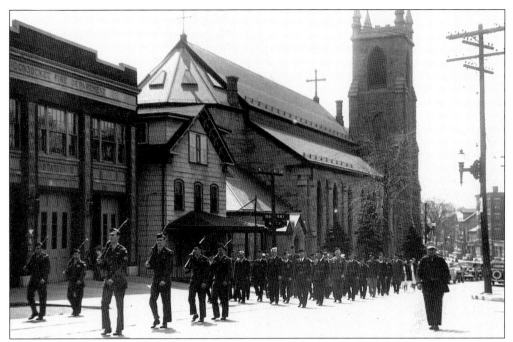

A parade proceeds along North Main Street c. 1940. In the background is St. Charles Borromeo Church, which was built between 1862 and 1871. Woonsocket's first Roman Catholic parish, the church was a stone Victorian Gothic structure, designed by New York architect P. C. Keeley. On the left is Woonsocket Fire Station No. 3. Built in 1926, the station is characteristic of early-20th-century firehouses. It is constructed of brick with glazed tile trim.

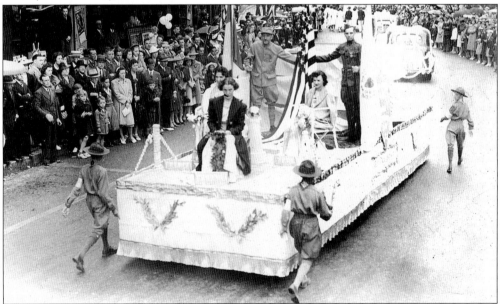

A parade float is pictured at Monument Square at the entrance to the Stadium Theatre on June 25, 1939. The float appeared in that year's St. John-the-Baptist Parade. French Canadians in the city yearly celebrated the festival of their patron saint with various activities. These observances took place each June from 1899 to the 1940s.

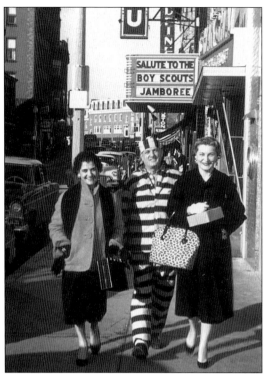

Mardi Gras revelers take a stroll along Main Street on February 8, 1956. In the background is the entrance to the Bijou Theatre, with a salute to the Boy Scouts' jamboree. Immediately behind the merrymakers is the entrance to the former Shanghai Restaurant. The theater and the restaurant are now just memories.

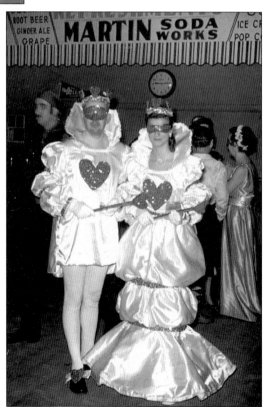

Masked revelers attend one of the many Woonsocket Mardi Gras masquerade balls. This one was held on February 14, 1956.

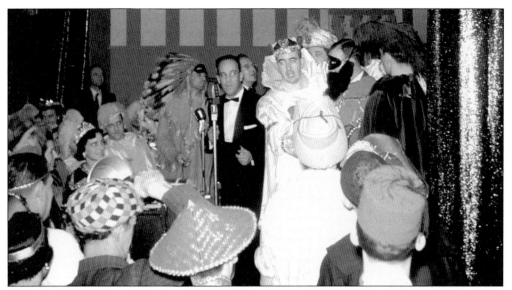

This photograph depicts the unmasking of King Jace at Woonsocket Mardi Gras on February 14, 1956. Gene Rousseau, of radio station WWON, is at the microphone as the unmasking takes place. The Mardi Gras masquerade ball at the Joyland Ballroom included an assortment of festivities during the evening and the awarding of prizes.

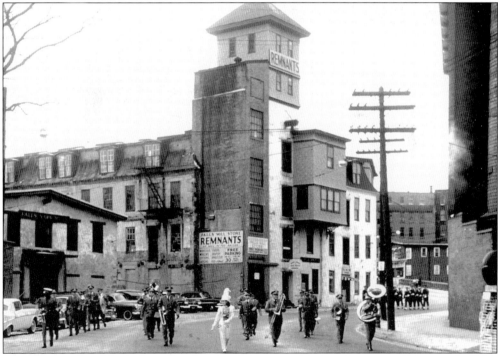

The Woonsocket Mardi Gras Parade is under way at Market Square on February 3, 1958. Unfortunately, the year was a typically cold New England winter, and with temperatures in the 20s, only 10,000 brave souls went outdoors to view the parade. The Market Square area underwent tremendous changes during the 1960s. The Thundermist Hydroelectric facility stands today in place of the structure seen in the center.

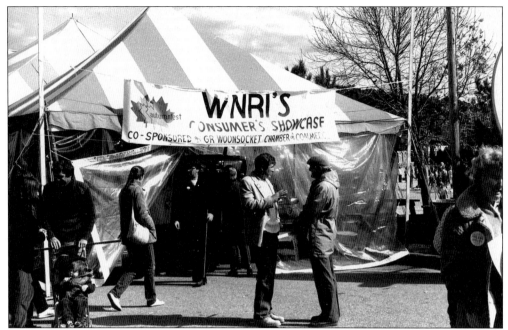

WNRI's Consumers Showcase, part of Autumnfest 1986, is held on Columbus Day weekend. The highlight of the festival is the two-and-a-half-hour Autumnfest Parade. In the World War II Memorial State Park, the live stage performances and exhibitors draw the crowds. The Consumers Showcase has long been a focal point of the festival. (Collection of Robert R. Bellerose.)

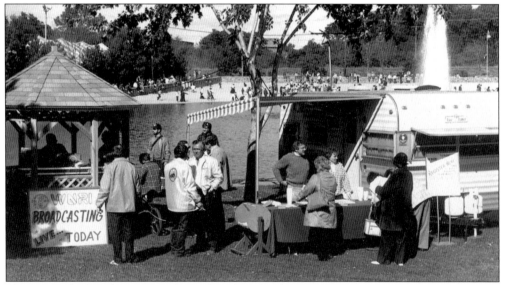

Shown are the broadcasting gazebo and trailer of radio station WNRI at Autumnfest 1986. In 1954, the Friendly Broadcasting Company, founded by Joseph Brito of Fall River, obtained a daytime license to operate at 1380 kilocycles on the dial. Local radio personalities Roger and Richard Bouchard, David St. Onge, and Robert D'Acchioli formed the American Independent Radio Corporation in 1983. That year they purchased WNRI and, by 1986, had transformed the station into a vital competitor in the regional media market. (Collection of Robert R. Bellerose.)

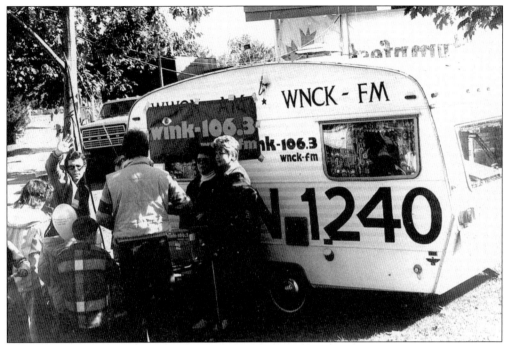

This photograph depicts the broadcasting trailer of radio station WWON and WNCK-FM at Autumnfest 1986. On January 19, 1986, a Rhode Island firm that included owners William Cerny and Miles Chandler purchased WWON. The new proprietors, at the time, focused their energy on improving the FM station, changing its programming to the more fashionable rock format. (Collection of Robert R. Bellerose.)

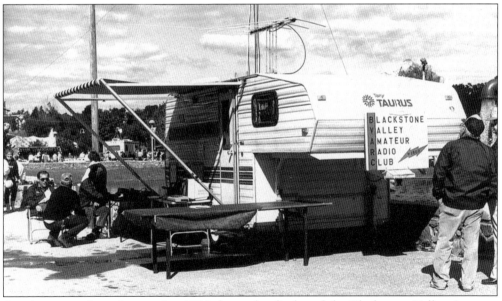

Another scene from Autumnfest 1986 shows the display of the Blackstone Valley Amateur Radio Club. Members of this club are dedicated to the hobby of amateur radio. During Autumnfest, visitors to this trailer had an opportunity to send a message to a family member anywhere in the world via radio relay. (Collection of Robert R. Bellerose.)

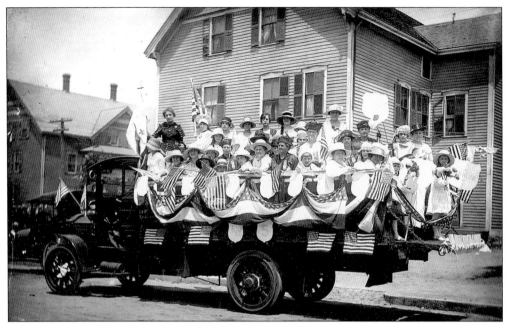

This photograph, taken in 1916, depicts the corner of Brook and Elm Streets. The scene is of a parade float, with one individual portraying St. Joan of Arc and others participating as members of a local fraternal organization. They are heading for the St. John-the-Baptist Day Parade. The celebration was held on June 24 annually from 1889 into the 1940s and included a parade, a picnic, and a concert.

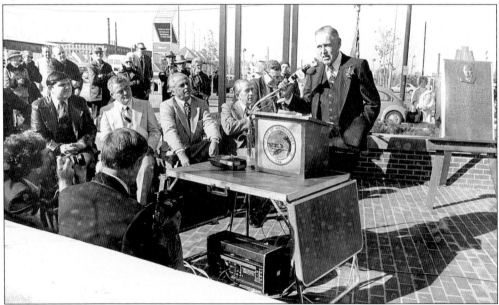

On Sunday, October 29, 1978, Woonsocket honors one of its favorite sons, Andrew Potter Palmer, the 70-year-old publisher-editor of the *Woonsocket Call*. Palmer is speaking at the podium, and seated are, from left to right, John Dionne, Mayor Gregory Bouley, and Congressman Fernand J. St. Germain. On that day the citizenry dedicated a carillon on Social Street in honor of Palmer.

Eight
COMMUNITY SERVICES

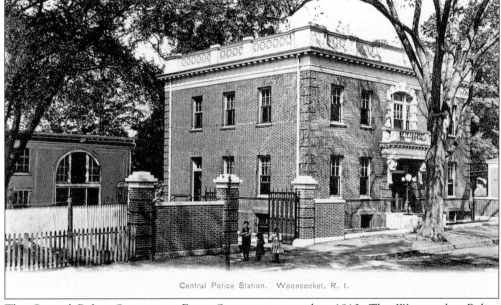

The Central Police Station, on Front Street, is pictured c. 1910. The Woonsocket Police Department moved from the Hope Building into this newly built structure in 1904. It served as the headquarters of the department until 1975, when the police moved to a new station built on Clinton Street. The magnificent two-level brick structure is remarkable for its intricately styled doorway and as an indicator of the architectural excellence the city required in the decades of its greatest prosperity. Walter Fontaine was the architect. Plans for this abandoned property call for conversion into housing.

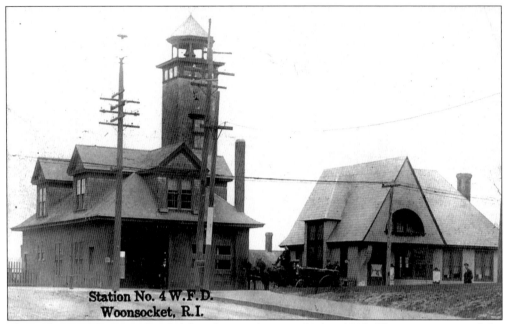

This is Station No. 4, on South Main Street, photographed c. 1910. The construction of the South Main Street fire station in 1902 cost $3,972. The entire cost including apparatus was just over $8,000. Construction for a replacement to this station occurred in the late 1960s on Providence Street.

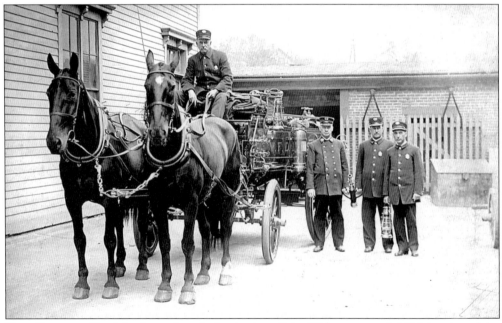

Hose Company No. 1 is pictured at the beginning of the 20th century. A 1911 inquiry of the Woonsocket Fire Department revealed that the department lacked new apparatus and a contemporary fire signal system. The report suggested the construction of two new fire stations; it recommended placing a station in the crowded Social District and replacing the outdated Bernon Street Station with another station.

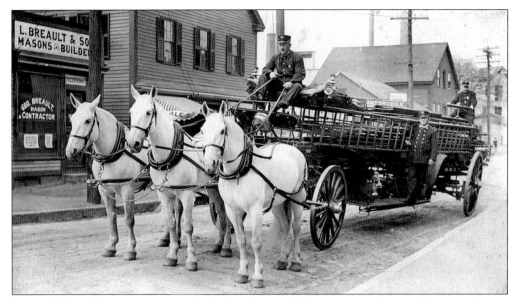

Driver T. Frank Lee is pictured with his first hitch of three horses at Station No. 1 on Bernon Street at the beginning of the 20th century. The modernization of the Woonsocket Fire Department started in 1913 with the acquisition of the department's first motor-propelled truck, nicknamed "Knoxy." Motorization went on until 1921, when new apparatus supplanted every horse-pulled contraption.

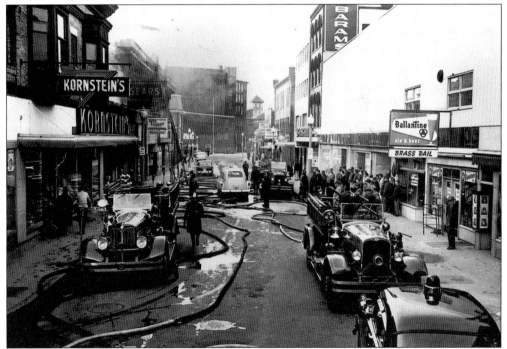

A serious fire damaged the Sears and Roebuck store, on Main Street, on March 8, 1958. The scene on Main Street has changed considerably. Kornstein's has long since gone out of business. Demolition of the building that contained Sears occurred years later, and many of the structures across the street were taken down long ago.

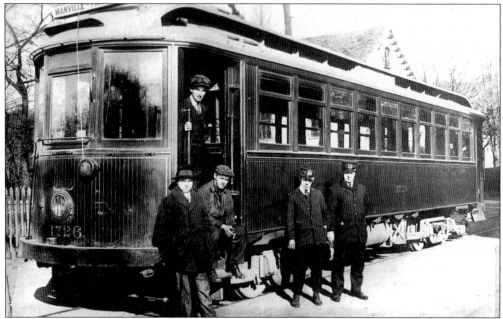

This scene depicts a trolley that once ran through the city at the beginning of the 20th century. Trolley No. 1726 began its route in the village of Manville, in the town of Lincoln. It ended its route in the Fairmount section of Woonsocket. The city had two long-route systems: the one in the Fairmount section and the other from North Main Street to the village of Pascoag, in the town of Burrillville. By 1906, there were routes on all the principal streets in Woonsocket and more than 70 miles of trolley routes radiated from the city.

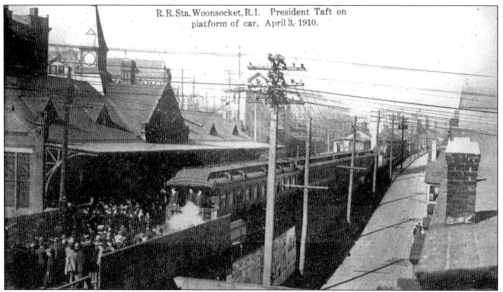

This 1910 scene shows Pres. William Howard Taft on the platform of his railroad car at the railroad station at Depot Square. This event occurred on April 2, 1910, when Mayor James Mullen led a gathering of 500 residents to the station to welcome the president. Press reports state that Taft's train stopped briefly, while the president positioned himself on the rear platform of his exclusive railroad car and conversed informally with the assembly.

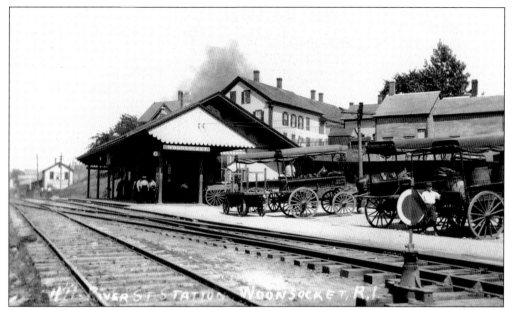

From the River Street station, the rail line (established in 1863) united Woonsocket with Boston. Later, in 1891, the line and station were incorporated into the Pascoag Extension. Through trains from Woonsocket to Boston last ran in 1926. Since 1973, the Providence & Worcester Railroad has operated the Pascoag Extension between Woonsocket and Slatersville. Shown at the beginning of the 20th century, the River Street station is no longer standing.

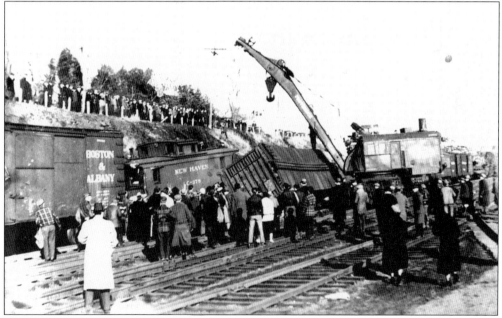

This c. 1940 photograph depicts the cleanup effort after a railroad derailment in the railroad yard just off River Street. Trains running off the rails were the most common type of railroad accident, and the "righting up" of railroad cars usually attracted quite a few spectators. This incident occurred while the New York, New Haven & Hartford Railroad was leasing the old Providence & Worcester line, as it had been doing since 1893.

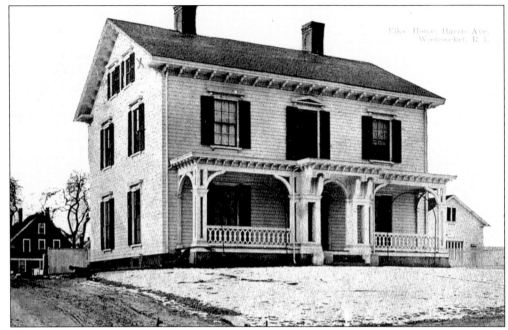

This is the Elks Home, on Harris Avenue, c. 1900. The Benevolent and Protective Order of Elks, a fraternal organization, has been active in Woonsocket since the late 19th century. Today, from an assembly hall on Social Street, the Elks remain active, supporting many civic projects through their charitable donations.

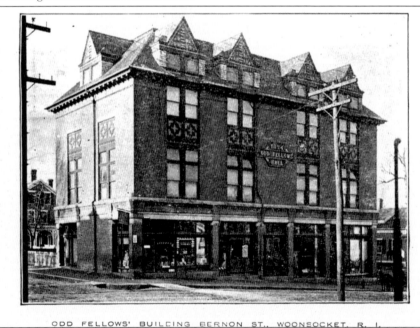

The Odd Fellows Building, on Bernon Street, is pictured at the beginning of the 20th century. Long since demolished, the building was a three-and-a-half-story, wood-embellished, brick business block, built c. 1893. It housed the assembly hall of the International Order of Odd Fellows. It also served at one time as the home of Jolicoeur Furniture Company.

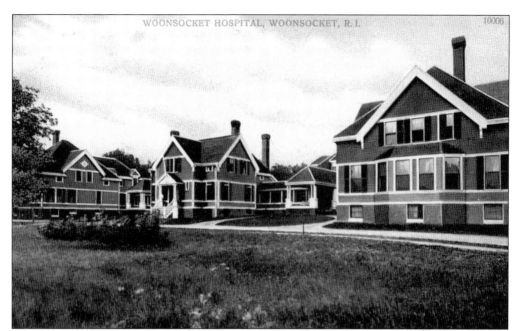

Woonsocket Hospital's original 1887 design called for the construction of cottages on Cass Avenue, shown c. 1900. Woonsocket's first hospital owes its existence to the progressive benevolence of Dr. Ezekiel Fowler. At his passing in 1863, Fowler left $6,000 to establish such an institution. However, Fowler's donation was insufficient to start a hospital. Additional money was necessary, and Latimer Ballou retained in trust the original donation. Ballou labored for decades before the hospital opened. In 1873, George Law bequeathed a large sum, and a hospital corporation was chartered in that year. Demolition of these cottages recently took place to make way for the hospital's new cancer-treatment center.

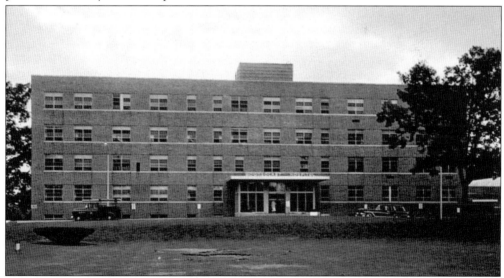

Woonsocket Hospital's grand entryway to its main building, on Cass Avenue, is pictured c. 1960. The building and property, now known as the Landmark Medical Center, have undergone quite a change since then. Today, the hospital boasts of a state-of-the-art center for the treatment of cancer and heart-related illnesses.

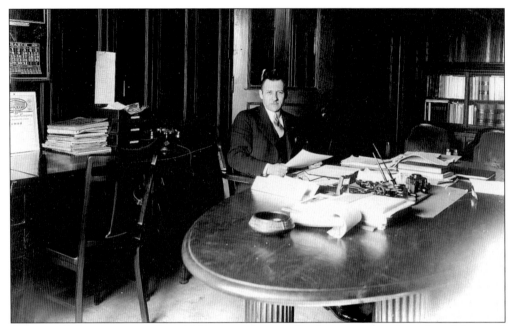

Antonio E. Prince, pictured in 1932, was active in local governmental, civil and fraternal affairs. In the 1934 state balloting, Prince beat Joseph Pratt, a Republican, to become the first citizen from Woonsocket to serve as general treasurer of Rhode Island. Prince was also Woonsocket postmaster from 1936 to 1964.

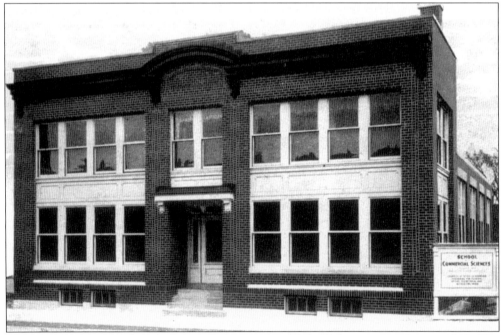

This view of the School of Commercial Sciences, on Federal Street, was taken c. 1900. The school's advertisement said that it occupied "the only building in this section to be erected exclusively for a private commercial school. Offers courses of study in branches preparing for general office, secretarial and accounting work." The school began operation in 1897.

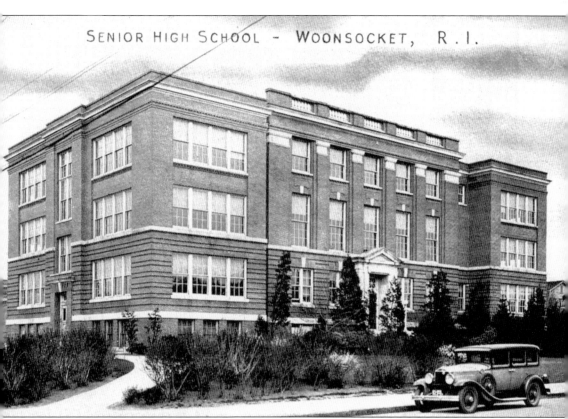

The senior high school, on Park Place, is pictured c. 1930. Constructed in 1914, with later additions not seen in this photograph, it is a three-level brick building with half-basement. Walter Fontaine conceived the design to intentionally create a striking and impressive municipal building that reflected the era—a time when Woonsocket achieved its greatest affluence. Today, this building is part of the Woonsocket Middle School.

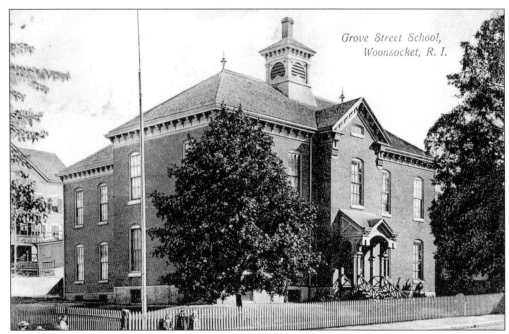

Grove Street School is pictured c. 1910. E. L. Angell conceived the details of this school, which was built between 1874 and 1876. It was originally a two-level brick Victorian schoolhouse with detailing and trim. It remains standing but has a new life as an apartment building.

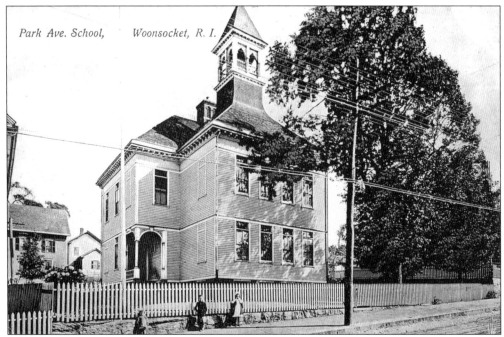

Park Avenue School is pictured c. 1910. The Woonsocket School Department had this school built in 1894 to answer the need for more schools in the late 19th century. Park Avenue School closed in 1960, when the Bernon Heights Elementary School opened, at a cost of $577,840.

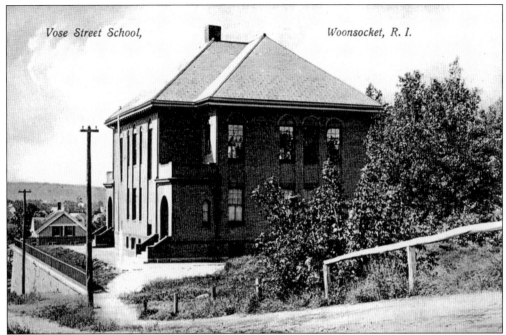

Vose Street School is pictured c. 1910. Clarence P. Hoyt of Boston conceived the design of the school, and in 1899 Napoleon Bouvier of Woonsocket built the structure. This plain but massive stone-embellished, brick, two-level structure originally held four classrooms. Today, this structure serves as an apartment building.

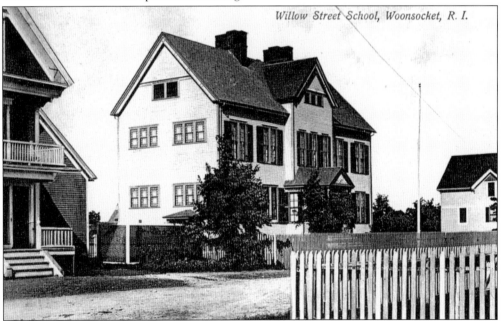

Willow Street School is pictured c. 1910. The years between 1891 and 1899 generated a need for more schools. Among the public schools built to answer this need was the Willow Street School, constructed in 1891. When Bernon Heights Elementary School opened in 1960, the school department vacated Willow Street School.

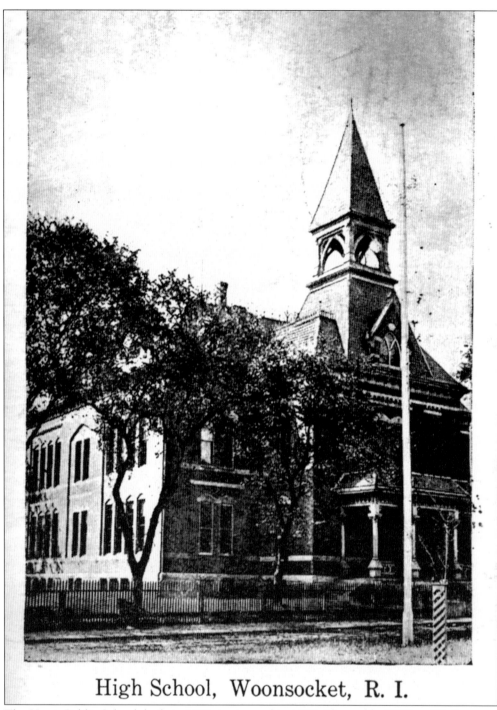

High School, Woonsocket, R. I.

The Harris Public School, built in 1876, is pictured in 1906. Planned by William Walker, one of Rhode Island's most notable late-19th-century designers, the school was constructed as the Woonsocket High School. It was the most ornate school structure in the area and was adorned with a bold tower, cut-granite casement caps, and belt courses. This structure was demolished to make way for a new Harris School, which opened in 2003.

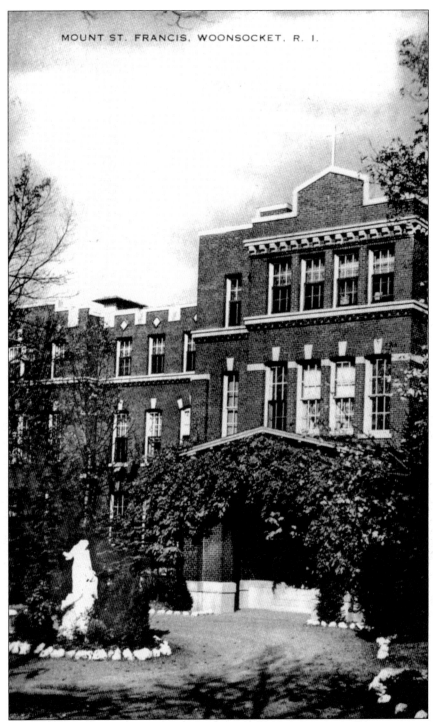

Mount St. Francis, built in 1911, is pictured c. 1940. Although the building was used as an orphanage then, the children housed within received an elementary school education. Walter Fontaine designed this institutional structure, with its minimal pseudo-Gothic features. Today, the building is the site of the Mount St. Francis Health Center.

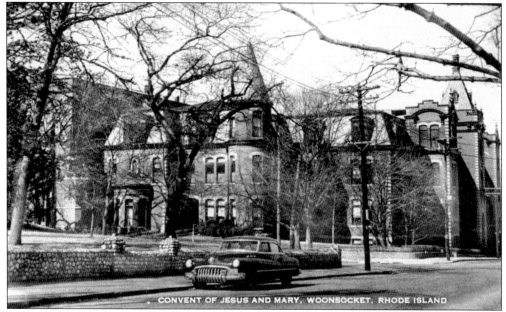

The Convent of Jesus and Mary, on Park Avenue, is shown c. 1950. This large complex dates from 1889, along with many additions and modifications. It began when the Reverend Charles Dauray, the pastor of the Church of the Precious Blood, established a convent-school named Jesus-Marie Academy. In 1911, the parish inaugurated a new, three-story girls' high school on Greene Street, designated St. Claire High School. These schools closed in the early 1970s, and conversion of the property into housing took place shortly thereafter.

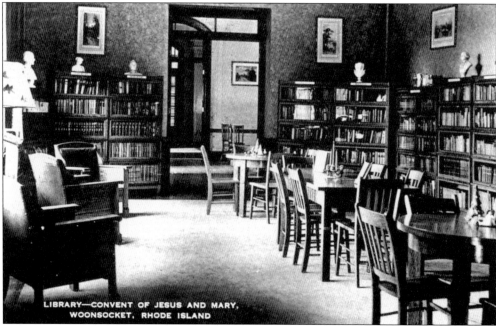

The library in the Convent of Jesus and Mary is pictured c. 1950. In this room the teaching sisters and students had access to a large collection of books, systematically arranged for reading and reference.

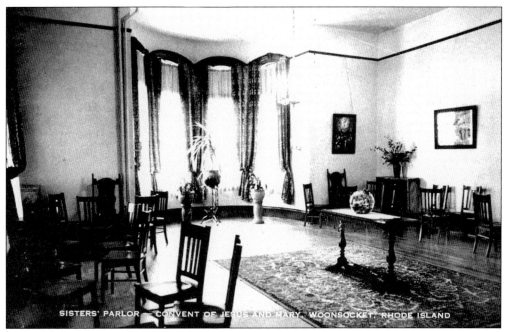

The sisters' parlor within the Convent of Jesus and Mary is shown c. 1950. This formal sitting room was set aside as a place for the *Religieuses de Jesus-Marie* to entertain guests.

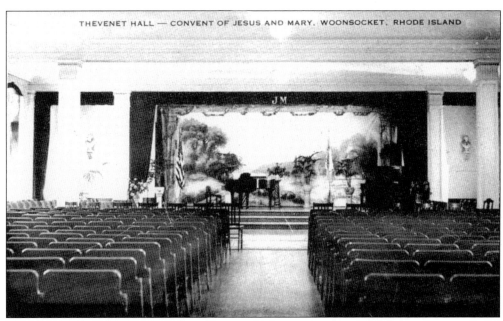

Thevenet Hall, within the Convent of Jesus and Mary, is shown c. 1950. In this "concert hall," recitals, concerts, plays, meetings, and other entertainments related to Jesus-Marie Academy and St. Claire High School were held.

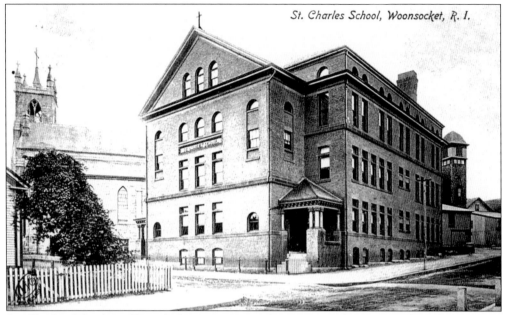

St. Charles School, on Daniels Street, is pictured c. 1909. Built in 1897, the school was an imposing brick building that was a blend of architectural styles. It was, nonetheless, a fascinating structure, historically important as a part of the story of St. Charles Borromeo Church, the city's oldest Catholic organization. The parish demolished the school in the early 1990s.

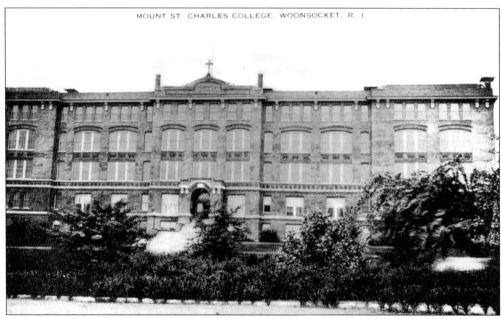

Mount St. Charles Academy, on Logee Street, is shown c. 1940. The school, established to educate high school–age boys, opened in September 1924 and was directed by the Brothers of the Sacred Heart. The academy is still a leading educational institution within the Catholic community. Coeducational since the early 1970s, most of Mount St. Charles Academy's classrooms remain quartered in its initial edifice, which was conceived by Walter Fontaine.

Nine
REMEMBERING THE MILLS

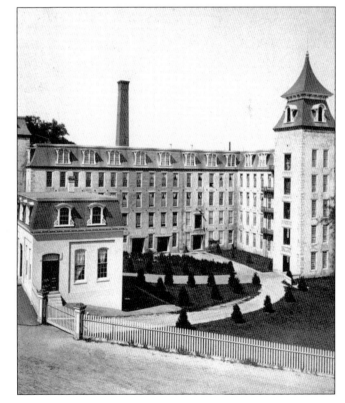

The Globe Mill stood between Front Street and the Blackstone River in the 19th century. Established by Thomas Arnold, Thomas A. Paine, and Marvel Shove, the Globe Mills commenced operation in 1827. In 1864, George C. Ballou became sole proprietor of the real estate. Construction of a mill addition, auxiliary structures, and mill houses was completed c. 1874. Demolition of the entire mill complex occurred in 1937.

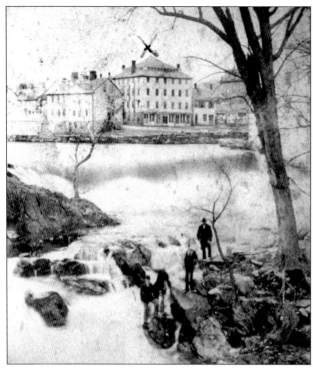

Woonsocket Falls is shown in 1871. The structure in the center is the old Woonsocket Hotel, at Market Square, built by Cephas Holbrook in 1832. At this point on the Blackstone River, the waterfall was the largest sole source of water energy in the Blackstone Valley, generating in surplus of 2,000 units in horsepower. It was this plentiful energy, and that of lesser brooks nearby, which led to Woonsocket's metamorphosis from an agricultural village into an industrial city. Flood-deterrent dams manage the river at this point today.

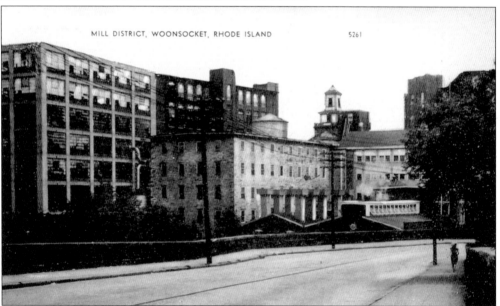

The mill district next to Woonsocket Falls is depicted here c. 1940. In the foreground is the Globe Bridge, which carries South Main Street over the Blackstone River. A parking plaza, costing $200,000, replaced these mills, which were razed in the late 1960s. The area was revitalized again in the 1990s and today contains wayside exhibits; however, it still serves primarily as municipal parking space. This installation, with guidance from the John H. Chafee Blackstone River Valley National Heritage Corridor, allows visitors a chance to learn about the history of the area.

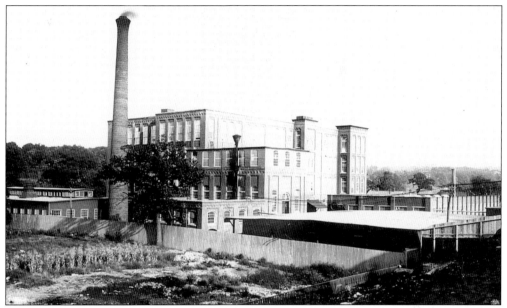

Lafayette Worsted Company, on Hamlet Avenue, is pictured c. 1910. Established in 1900 by Auguste Lepoutre et Cie of Roubaix, France, this became the first mill in Woonsocket to employ the French spinning method. When constructed, the extensive compound, adjoining the banks of the Blackstone River, became the biggest textile mill in Woonsocket. In August 1955, because of the flood of that year, the mill ceased operations. Unique in Rhode Island are the mill's Beaux Arts–style offices, at 134 and 150 Hamlet Avenue.

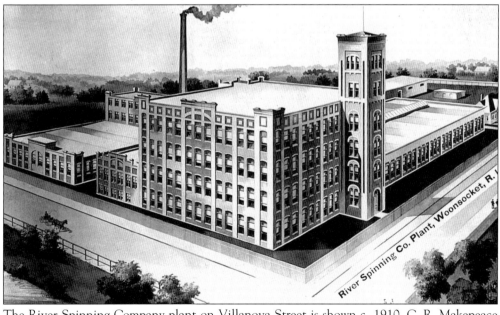

The River Spinning Company plant on Villanova Street is shown c. 1910. C. R. Makepeace and Company, mill engineers, conceived this stunning textile mill compound for W. F. and S. C. Sayles in 1894. Here, 150 workers produced woolen and merino threads by the French method. In the second decade of the 20th century, the complex became the Florence Dye Works. A spectacular fire in 2003 destroyed the entire property.

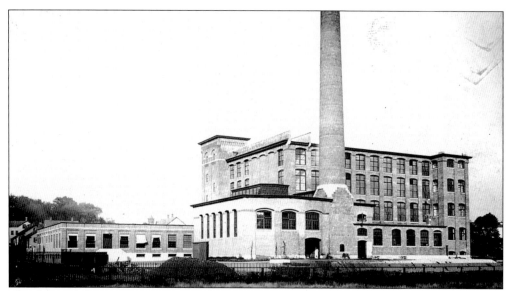

The former Jules Desurmont Worsted Yarn Mill, on Fairmount Street, is pictured c. 1910. A comparison of this image with the one below reveals the structures that have been added over the years. Jules Desurmont and Sons, of Tourcoing, France, a major owner of woolen textile mills, set up operations in the Fairmount Street mill in 1907. The operation was incorporated in 1909 with a capitalization of $1.5 million. Although the company did not produce finished goods, the yarn made in this mill was in use nationwide. Later, this site became the Riverside Worsted Company.

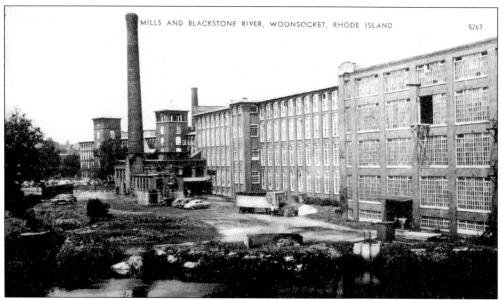

The former Jules Desurmont Worsted Yarn Mill, located along Water Street, is shown from the rear c. 1940. The yarn mill is in the foreground, with the Alice Mill of the United States Rubber Company in the background. In 1928, Eugene A. Bonte moved from France with his family and became the new assistant manager of the Woonsocket operation. In 1952, Bonte purchased Desurmont's interests in the United States and formed the Bonte Spinning Company.

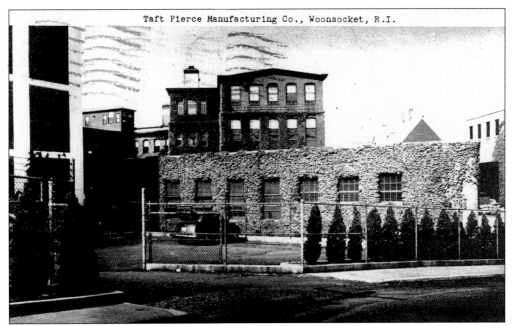

The Taft Pierce Manufacturing Company, on Mechanic Avenue, is pictured *c.* 1950. The Taft Pierce compound dates back to the 1860s as the site of Elliott's Lumber Yard and Planing Mill. By 1895, the Wardwell Sewing Machine Company was here. By 1910, Taft Pierce had moved in, and in 1916, the company built what later became known as the Bancroft structure on Bancroft Court.

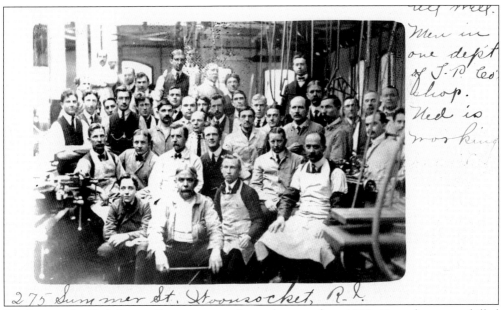

Workers at the Taft Pierce Company pose for a photograph *c.* 1906. Over the years, skilled employees such as these men produced a variety of items, including typewriters, specialty machines, tools, auto industry products, and tabulating machines. During World War II, Taft Pierce workers produced precision valves, radar equipment, torpedo parts, and a host of diverse war materiel.

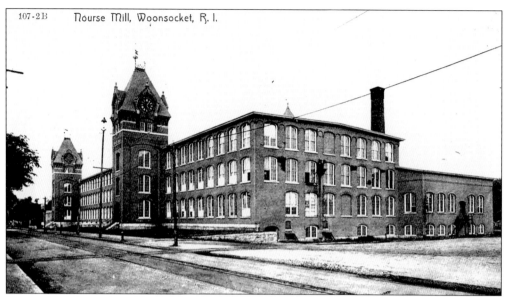

Nourse Mill, located on Clinton Street, is shown c. 1910. Residents witnessed the construction of this cotton-manufacturing mill in 1883. In the early 1900s, the Manville Company bought the mill. The plant ceased operations as a cotton mill in 1927, but following two years of being dormant it became the location of a rayon-manufacturing business. There was rioting at the mill during the widespread textile strike in 1934. The plant shut down permanently in 1949 and was destroyed by a dramatic general-alarm fire on October 6, 1956.

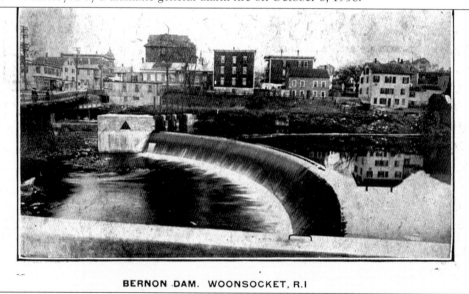

Bernon Dam and vicinity are pictured c. 1900. This dam created a reservoir of water from the Blackstone River. A controlled flow of water sent into a power trench conducted this resource to the Woonsocket Company Mills downstream. The tenement houses on the opposite shore are on Front Street. The mill village of Danville dates to 1827, when Dan Daniels and Jonathan Russell, in partnership, formed the Russell Manufacturing Company. Unfortunately, the partnership went bankrupt in 1829. Sullivan Dorr and Crawford Allen bought the mill properties in 1832, formed the Woonsocket Company Mills, and renamed the village Bernon.

Ten
PLACES OF WORSHIP, COMFORT, AND REST

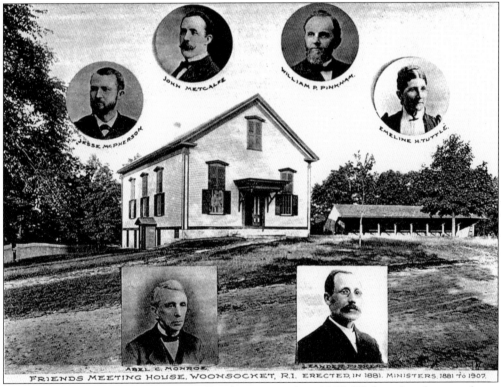

The Friends meetinghouse, on Great Road, is pictured in 1907. Within the photograph are images of the ministers who served from 1881 to 1907. From left to right are the following: (lower row) Abel C. Monroe and Leander Fisher; (upper row) Jesse McPherson, John Metcalfe, William P. Pinkham, and Emeline H. Tuttle. John Arnold and other Quakers in 1720 built the first religious structure in northern Rhode Island on the site of the present meetinghouse. Considering the era in which construction took place, the present structure exhibits exceptional austerity. The existing meetinghouse is a one-level clapboard building with very little ornamentation and no steeple; it resembles a structure of 1848 rather than 1881. There is, nevertheless, an air of stateliness and function about it.

The First United Methodist Church, on Federal Street, is pictured c. 1960. Since 1836, the Methodist congregation of Woonsocket had worshiped in a wooden edifice on nearby Main Street. In 1908, the congregation relocated to its new church, a wide, concrete cube-shaped temple with an entrance under a square tower in the front. The church also features grand, decorative, stained-glass windows. An addition of stucco painted in ivory was applied at a subsequent date.

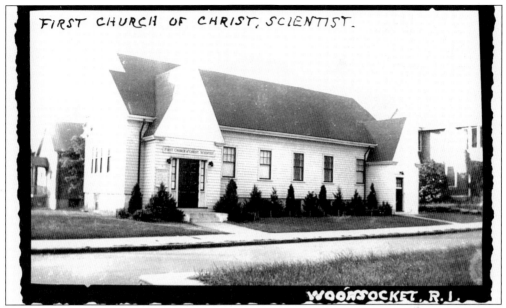

First Church of Christ, Scientist, at 95 Bernice Avenue, is shown c. 1960. This congregation was established in 1914. Following the passage of two years, the church organized a reading room in the Commercial Building, on Main Street. In the 1970s, the local congregation dissolved, and in later years the property was remodeled and converted into a private home consisting of two apartments.

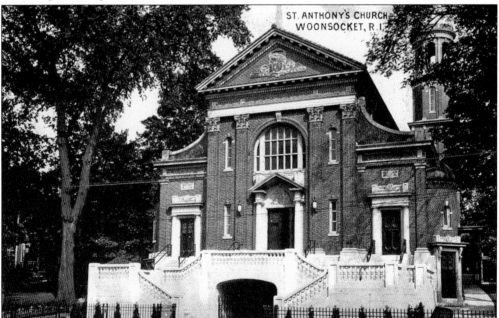

St. Anthony's Church, on Greene Street, is shown c. 1930. The primary mission of this Roman Catholic parish was to minister to its largely Italian flock. This structure is a superb example of a Baroque-style church fashioned after Italian churches of the 17th century. Conceived by Ambrose Murphy, the church was built by Joseph Donatelli in the late 1920s. The building is constructed in brick, with a gold-domed campanile, and has a fine barrel-vaulted interior.

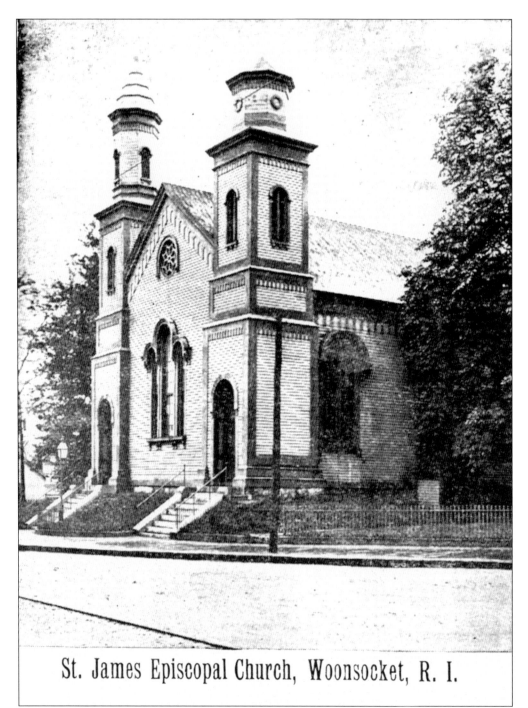

St. James Episcopal Church, Woonsocket, R. I.

St. James Episcopal Church, on Hamlet Avenue, is pictured c. 1900. This original house of worship dated from 1833, when the St. James parish was established. The hurricane of September 1938 blew 200 slates from the roof and caused water damage to the ceiling and the new organ. The church was replaced with the current structure, which was dedicated on January 1, 1939.

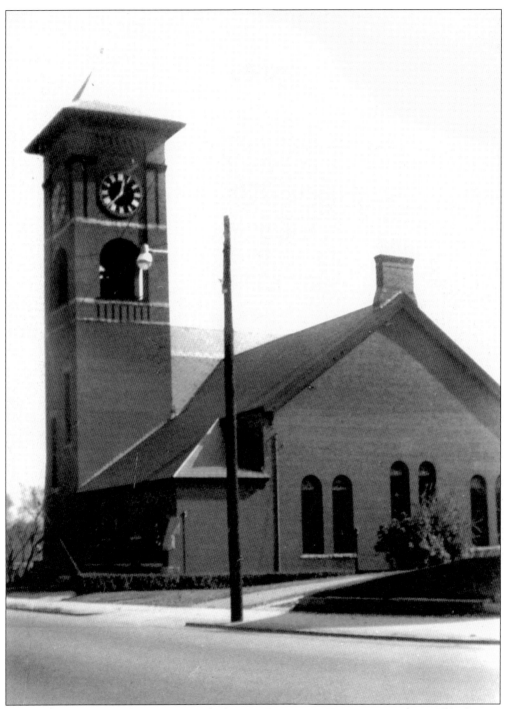

The First Baptist Church, built on Blackstone Street in 1891, is pictured c. 1950. A very beautiful brick house of worship, heightened by a 60-foot steeple, the church is noteworthy for its fine stained-glass windows. The church was designed by architect William Butterfield of Manchester, New Hampshire, and was constructed by Darling Brothers of Worcester. The cost was approximately $29,000.

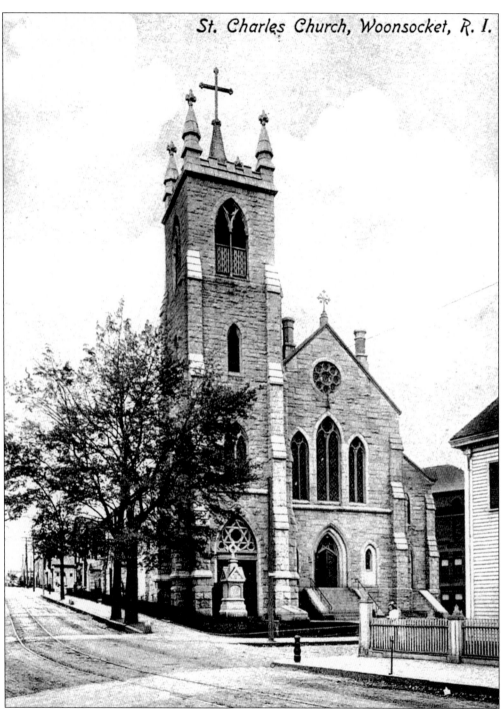

St. Charles Borromeo Church was built on North Main Street between 1862 and 1871. Shown here c. 1900, the church is made of granite and is a fine example of a Victorian Gothic structure. St. Charles Borromeo was built by the area's first Catholic parish and was designed by P. C. Keeley, a notable New York architect who dedicated his life to designing Catholic houses of worship.

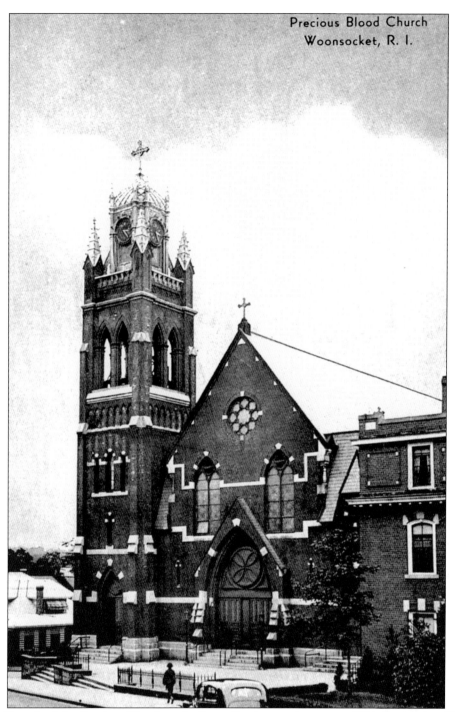

The Church of the Precious Blood was built on Carrington Avenue in 1881. Pictured c. 1940, this is the oldest French Canadian house of worship in Woonsocket. Work on an edifice was started in 1874, but that building was damaged and was later supplanted by the present-day structure, designed in part by W. F. Fontaine and Sons. The striking copper-embellished belfry is an early-20th-century modification.

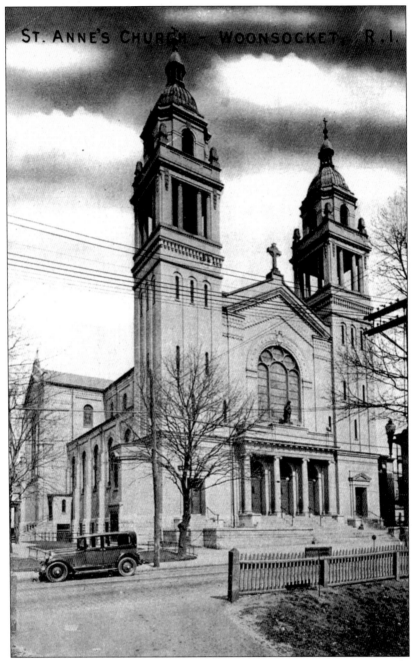

St. Ann's Church was constructed on Cumberland Street between 1914 and 1918. Shown here c. 1930, it is architecturally Woonsocket's most splendid church, magnificent and massive within and without. Walter Francis Fontaine was the creator of this twin-towered, yellow brick structure. On August 12, 1918, Msgr. Peter Blessing of the Diocese of Providence presided at the consecration and the blessing of the bells at the new, $150,000 St. Ann's Church. Guido Nincheri adorned the inside with murals painted between 1941 and 1953. Sizeable statues and fine marble ecclesiastical furniture enhance the décor. Today, this structure no longer serves as a parish but is the St. Ann's Arts and Cultural Center.

The priests assigned to St. Ann's Church, on Cumberland Street, are pictured *c.* 1913. They are, from left to right, Rev. Joseph Fauteux, Rev. Henri Gaudent, Rev. Napoleon Leclerc, and Rev. Joseph Dumont. According to the parish census of 1913, Father Leclerc, the pastor, and his assistants were responsible for nearly 1,100 enrolled families, numbering almost 6,000 souls.

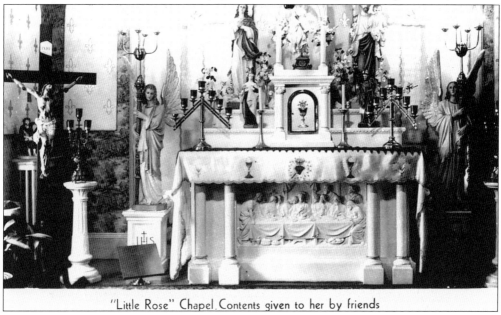

The Little Rose Chapel is pictured *c.* 1957. Marie Rose Ferron (1902–1936), known as "Little Rose," was reputedly a soul of heroic holiness during her lifetime. Many of her relatives, benefactors, and devotees maintained that she was prone to a host of wondrous revelations of a "mystic nature" including the stigmata, ecstasies, visions, and prophecies. A small shrine dedicated to "Little Rose" was located for many years in a private home. The site on Providence Street contained a chapel with many items related to her life and religious items given to her by friends.

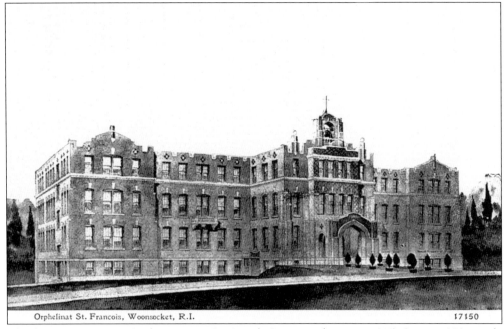

The former St. Francis Orphanage, on St. Joseph Street, is shown c. 1915. Some 1,200 people witnessed the dedication of the orphanage atop Logee Hill on September 22, 1912. This structure, designed by Walter Fontaine, was an institutional building with simple pseudo-Gothic detailing. The facility was designed to hold more than 300 children. In 1984, the Mount St. Francis Health Center opened its doors here.

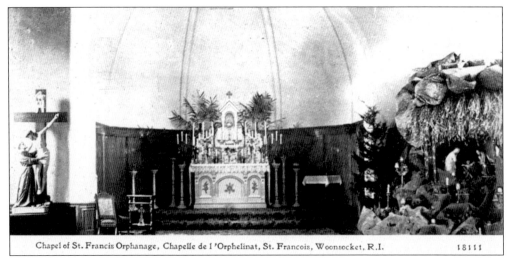

The Chapel of St. Francis Orphanage is shown during the Christmas season c. 1920. Plans for an orphanage began in January 1904, when two nuns from the Franciscan Missionaries of Mary came to Woonsocket. They had accepted an invitation from the Reverend Charles Dauray, the pastor of the Precious Blood parish. When the nuns arrived, their initial assignment was the care of three small girls orphaned by the death of their mother. To provide shelter and schooling for the children, the nuns first used a wooden building on Hamlet Avenue, near Precious Blood Church.

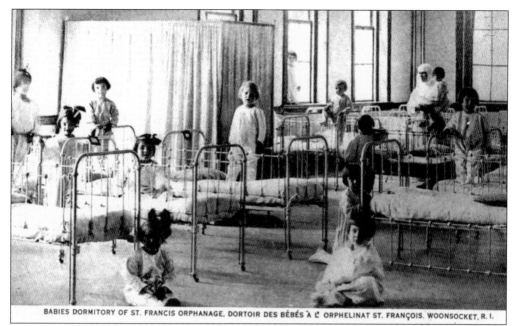

BABIES DORMITORY OF ST. FRANCIS ORPHANAGE, DORTOIR DES BÉBÉS À L' ORPHELINAT ST. FRANÇOIS, WOONSOCKET, R. I.

This is a view of the baby's dormitory within the St. Francis Orphanage c. 1920. By the time the orphanage closed in 1973, the nuns had cared for more than 12,000 boys and girls. Later, a day-care center used the facility. In 1984, the Mount St. Francis Health Center opened at the site and continues to operate there today.

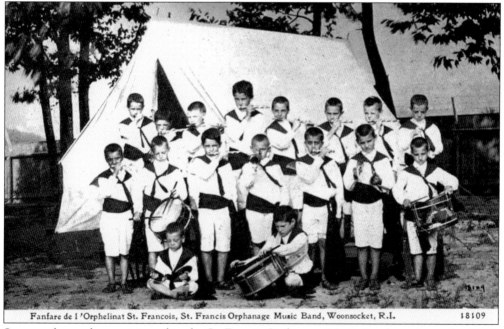

Fanfare de l'Orphelinat St. Francois, St. Francis Orphanage Music Band, Woonsocket, R.I.

Some orphans who participated in the St. Francis Orphanage Music Band are pictured c. 1920. The orphanage's operation would not have been possible without the large $60,000 donation by Dr. Joseph Hils.

Rev. Achille Prince poses for a photograph c. 1920. In 1914, he replaced Fr. Mederick Roberge as pastor of St. Louis de Gonzaga Roman Catholic Church. Under Father Prince's guidance, the parish built a convent and, in 1922, began renovating the George Street School by adding a third floor and brick façade. Father Prince was remembered fondly by parishioners for many years.

This was the funeral procession of Rev. Mederick Roberge (1863–1931) in front of St. Louis Church on March 20, 1931. Father Roberge was the founding pastor in 1902 of St. Louis de Gonzaga Roman Catholic Church. The church, located on Rathbun Street, is today known as All Saints Parish. Bishop Matthew Harkins, D.D., of the Diocese of Providence asked for Father Roberge's resignation in 1914, after an examination of the parish's books revealed questionable financial affairs. Bishop Harkins allowed Father Roberge to continue to live in the rectory as an assistant after he stepped down.

The Boyden family plots in Oak Hill Cemetery are shown in this 19th-century image. Known throughout the community, the Reverend John Boyden (1809–1869), interred here, was "pastor of the Woonsocket Universalist Society for thirty years." In the mid-19th century, Edward Harris established this picturesque burial ground on a hilly site overlooking the city. Here rest many renowned local residents.

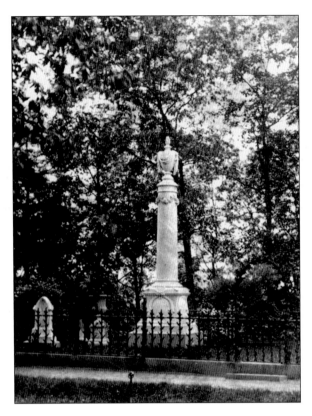

This scene in Oak Hill Cemetery was taken in the 19th century. Shown is the grave site of Samuel Simms Foss (1821–1879). Inscribed on the tombstone are the words "An eminent journalist, distinguished for philanthropy, generosity to the unfortunate, great love of kindred, a foremost toiler in all good works." For 40 years Foss was the publisher of the *Woonsocket Patriot*, the city's first newspaper, which began publication in 1833 from a building near where city hall is today.

This is a 19th-century view of the Jenckes family burial ground in Oak Hill Cemetery. The Jenckes family was active in the early affairs of northern Rhode Island, especially in the area that would become the city of Woonsocket. Some family members buried here include George Jenckes (1799–1868), William H. Jenckes (1823–1877), Edwin Jenckes (1826–1895), George W. Jenckes (1829–1913), Leander Jenckes (1832–1861), and Ferdinand L. Jenckes (1834–1913).